Beginner's Guide to
Hardanger

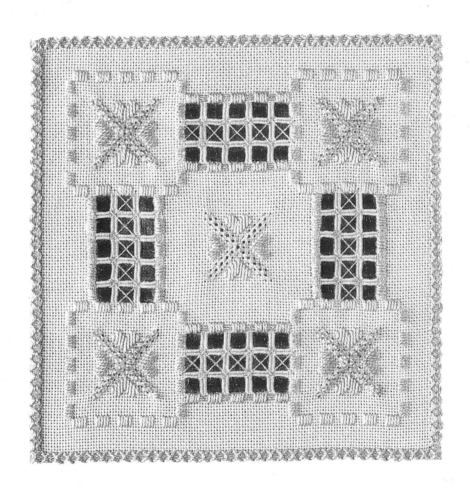

*For my daughter, Venetia
and my son, Hugo*

Beginner's Guide to
Hardanger

Jill Carter

SEARCH PRESS

First published in Great Britain 2003

Search Press Limited
Wellwood, North Farm Road,
Tunbridge Wells, Kent TN2 3DR

ISBN 1 90397 522 0

The Publishers and author can accept no responsibility for any
consequences arising from the information, advice or instructions
given in this publication.

Readers are permitted to reproduce any of the embroideries in this
book for their personal use, or for the purposes of selling for
charity, free of charge and without the prior permission of the
Publishers. Any use of the embroideries for commercial purposes is
not permitted without the prior permission of the Publishers.

Suppliers
If you have difficulty in obtaining any of the materials and
equipment mentioned in this book, please visit the Search Press
website for details of suppliers: www.searchpress.com

Alternatively, you can write to the Publishers at the address above
for a current list of stockists, which includes firms who operate a
mail-order service.

Publisher's note
All the step-by-step photographs in this book feature the
author, Jill Carter, demonstrating Hardanger embroidery. No
models have been used.

Acknowledgements

*I would like to thank both Kate Haslam and Jan
Harry for their generous support and skills in working
the projects on pages 41/57 and 49 respectively.*

*Thank you to the hard working and dedicated team at
Search Press led by Roz Dace, my editor
Sophie Kersey and designer Juan Hayward, who have
put this book together with such interest and
enthusiasm. A particular thank you to Lotti for her
photographs and for making the photography shoots so
special. Many thanks go to Siriol Clarry for her
painstaking diagrams and charts.*

*I gratefully acknowledge with much appreciation the
support and generous contributions given to me for
the projects by Alistair McMinn of Coats Craft UK,
Cara Ackerman of DMC Creative World, Vartan and
Sarah of Sew it All Ltd, Kreinik Manufacturing
Company Inc. and Craft Creations Ltd.*

*Finally, thank you to Mrs Elizabeth Arneberg and
Mrs Aase Walker, who have both kindly entrusted me
with their Hardanger bunad (folk costume) for
photographs in this book.*

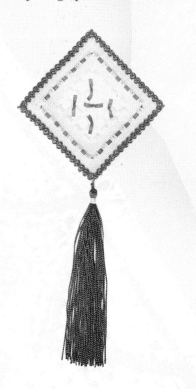

Contents

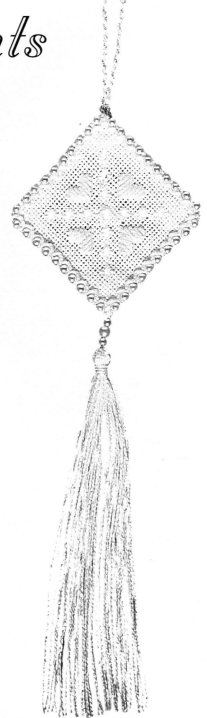

Introduction

Hardanger embroidery is a counted thread technique incorporating drawn thread embroidery and filling stitches. The beauty of this white work technique lies in the negative and positive of the delicate openwork fillings, which contrast with the heavier surface embroidery. Thought to have its origins in the Middle East and Asia, the technique is believed to have spread to Europe during the Renaissance, where it evolved from the Italian needle-made 'lace' known as Reticella. Hardanger embroidery has developed over the years into its present form and is now associated with the Hardanger region of southwest Norway, from where it takes its name.

An antique Hardanger band from the apron of a folk costume belonging to Mrs Elizabeth Arneberg.

Today Hardanger embroidery decorates household items, ecclesiastical pieces, and clothing. It is an important feature of the traditional folk costume (*bunad*) of the Hardanger region, where it is found as an inset on the apron and on the cuffs, collar and front flap of the women's blouse, (as shown on the opposite page) and on the cuffs and collar of the men's costume. The continuing popularity and ever widening interest in Hardanger embroidery, combined with pride in and appreciation of folk costume in Norway will ensure a safe future for this traditional technique.

I came to love and enjoy Hardanger embroidery when I lived in Oslo in 1967, where I learnt the technique from a highly skilled needlewoman who had stitched this special and disciplined work all her life. It occupied a greater part of her time and provided much needed stimulation during the long, hard Norwegian winters.

For an embroidery technique to survive through succeeding generations, it is important for it to continue to develop from its original traditions.

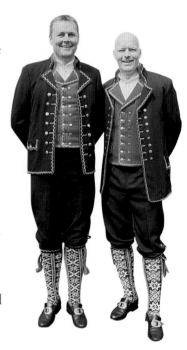

Above and left: Traditional bunad (folk costume) from the Hardanger region photographed on Norway's Constitution Day.

Although it is an introduction to Hardanger, this book will also embrace all those who would like to further their knowledge and try out the developments I have made with the introduction of beads and paint and some other novel ideas for decorative fillings.

Introducing beads into the filling stitches has produced a unique addition to the finished effect of the embroidery and one which I like more and more, as I feel that it does not compromise the origins and look of the technique.

Try out simple painted background effects or enjoy the clarity and simplicity of white on white. Experimenting with the ideas will bring you endless hours of pleasure and fulfilment, and, I hope, a new love of this wonderfully decorative embroidery technique from Norway.

Jill Carter

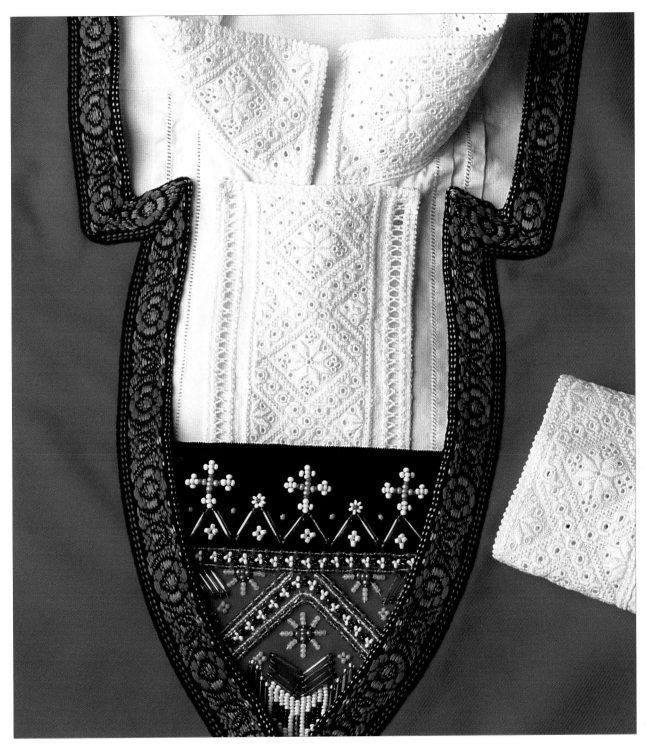

A woman's traditional bunad (folk costume) from Nordheimsund in the Hardanger region of Norway, showing Hardanger embroidery on the blouse. The small decorative bead-embroidered square is attached to the blouse under a sleeveless jacket edged with braid. This is worn with a black skirt and a white apron with a Hardanger inset and jewellery specific to the area or inherited by the wearer. The Hardanger design on this costume was worked by Mrs Aase Walker, to whom it belongs. The bunad will be worn on Norway's Constitution Day and other special and family occasions such as weddings.

Materials

Fabric and needles

Hardanger embroidery is worked on evenweave fabric in order for the threads to be cut, withdrawn and embellished. Fabrics have different properties and it is best to choose one to suit the use for which the embroidery is intended and of a count (threads to the inch) that you can see. The greater the number of threads to the inch, the finer and more delicate your work. Your time and work is precious, so always buy a good quality fabric. You will find suitable fabrics with counts of single threads from 18 to 32 threads to the inch in linen, linen mixes, cottons, cotton mixes, and Hardanger/Oslo fabric which has a double thread count. The decision is yours and should be governed by the final effect you want to achieve, but do not be afraid to experiment if you find a new and exciting fabric.

Linen evenweave is easy to stitch and pull, gives wonderfully fine and lacy effects and is probably the most luxurious to sew on. Cotton mix fabrics come in a wide range of colours and counts, one of the most useful being a 25 count cotton and rayon mix. This fabric will keep its shape when you are working on large areas of cut work, the end results look 'crisp' and it washes well. Twenty-five count is a good alternative for those who find the finer counts trying on the eyes but who still want delicate effects. Painted effects are also easily achievable on cotton mixes (see page 35).

All the projects in this book may be worked on any fabric count of your choice, but the final results and dimensions will vary in size accordingly.

Needles

You will need blunt-ended tapestry needles in sizes suitable for the fabric count. Usually this is size 24 or 26. Special blunt-ended tapestry needles in size 10 will be necessary for threading and working with beads in the fillings. A crewel needle in size 10 is a useful alternative, although it has a sharp end which makes it harder to work with.

Opposite

This selection of evenweave fabric shows the variety from which you can choose and includes one which has been painted. The rich sheen on silk makes an excellent backing fabric to offset your embroidery. The Hardanger tablecloth was my first piece (now thirty-five years old), worked on 35 count Irish linen with linen thread.

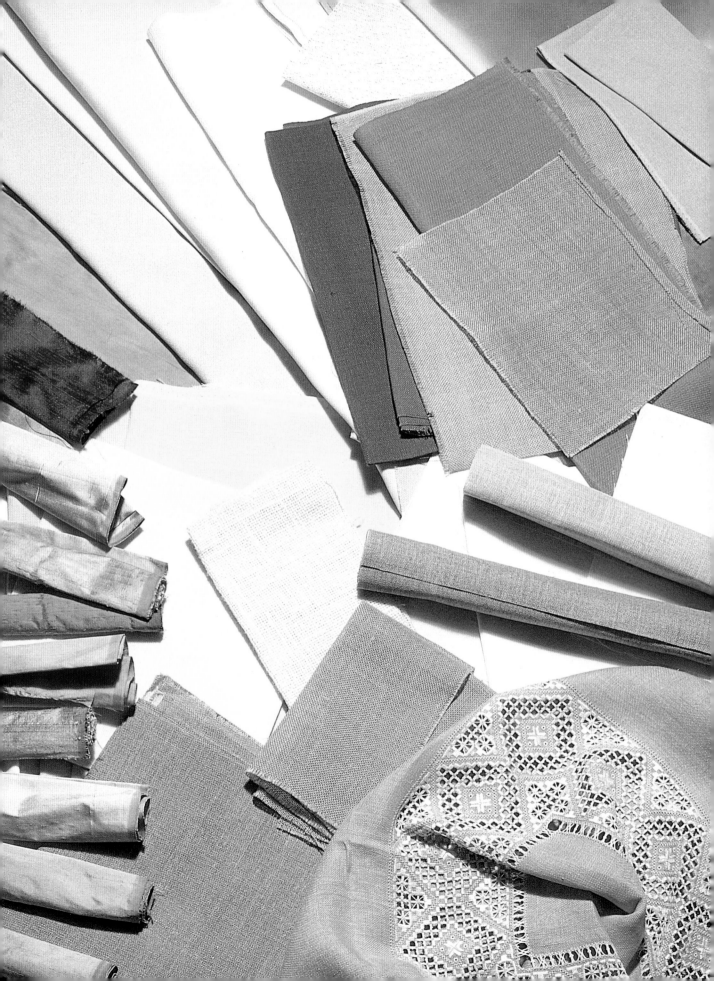

Threads and decorative items

A thicker and a finer thread are needed for Hardanger embroidery. The thicker thread is used for kloster blocks, surface embroidery and border stitches and should be slightly thicker than the background warp and weft so that when worked, the stitches touch each other and look slightly raised. The finer thread is used for the needleweaving, filling stitches, pulled thread embroidery (eyelets and reversed diagonal faggoting) edging and hem stitching and should be marginally thinner than the background warp and weft in order to achieve the delicate effects.

The wonderful choice of threads readily available from plain to shaded colours, from matt to shiny textures is sometimes bewildering. Using coton perle (also called pearl cotton) is a good starting point, as it comes in a number of thicknesses and colours. The fabric count determines the thicknesses of thread you will need for your embroidery. For example, for fabrics with a 24 count or less, you will need no. 5 for the surface embroidery and no. 8 for needleweaving and pulled thread techniques. On 25/26 count fabric, you will have to choose from no. 5 to 8 for the thicker threads and 8 to 12 respectively for the finer work. Numbers 8 and 12 are used for 27 to 32 count fabric.

There are a variety of alternative threads which could be used for your Hardanger, such as linen, silk and metallics. When choosing a metallic thread, find one which is flexible and will lie flat when

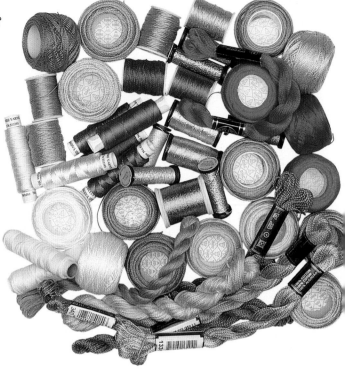

needleweaving. Iridescent blending filament is an excellent choice to combine with other threads for that discreet touch of sparkle in your finished piece. Shaded threads can 'overpower' the stitchery and do not always give the effect expected, so use them with care and choose ones which do not have sharp contrasts in them.

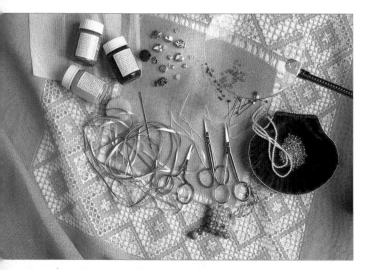

Decorative items

Good sharp, fine scissors, which cut 'to the point' are essential. There are various types, so-called 'specific for the technique', but simply choose ones that you like and which work well for you.

Use a magnifying glass and wax if you need to. The wax will help to stiffen the end of the thread for threading through fine needles for the beaded fillings.

A flat bodkin is useful for threading fine ribbon through blocks or stitchery.

Seed and pearl beads, ribbon and transfer paints are used to embellish embroideries.

Other items

The items shown here are extras to help you with your presentation.

Using an embroidery frame is a personal choice, but not essential. If you decide to work in a frame, use it for the kloster blocks only and remember to remove the work from the frame when you have finished stitching.

Small amounts of spray starch on the back of cut and drawn threads stabilise the threads on loosely woven fabrics, making it easier to keep the shape of the grids on which to needleweave.

Seductively coloured or textured papers make excellent instant backgrounds to set off your Hardanger embroidery.

Aperture cards come in many colours and sizes and give an immediate frame to your work, avoiding the necessity for hemming and edging.

Should you decide to cut your own mounts out of card, work on a proper cutting mat. Use a craft knife with a retractable blade for safety and cut against a good metal ruler.

Spray mount or double-sided tape will enable you to move your embroidery if you are mounting it in a card or on paper and it is not completely straight the first time.

Materials used for the presentation of finished embroideries.

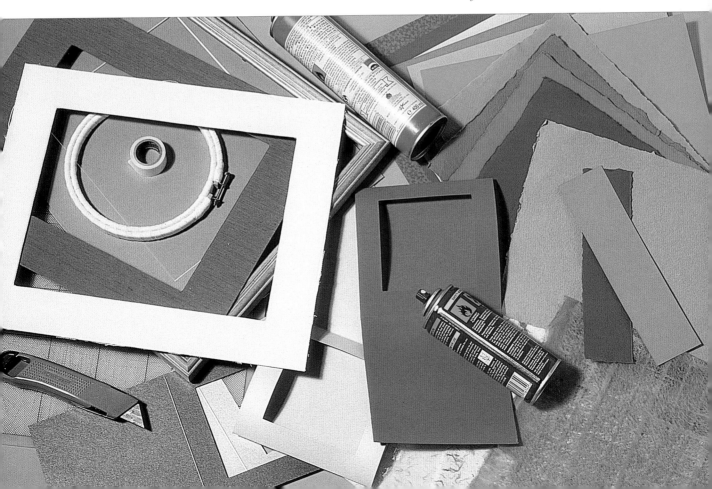

Techniques

Traditionally Hardanger is a white work technique, but all the stitch techniques shown in this book have been worked in a contrasting colour for clarity.

Surface stitchery

Surface stitchery and motifs are an important feature of Hardanger embroidery and create contrast and texture against the delicate openwork. As a general rule surface stitchery requires the thicker of your two threads.

Satin stitch

This simple straight stitch requires the thicker of your two threads, which should be chosen to suit your fabric count (see page 10).

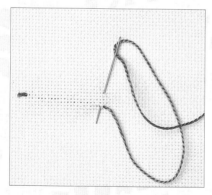 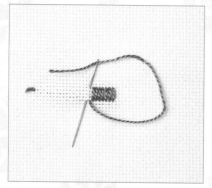

1. Bring the needle to the surface and back down again through the fabric, four threads up.

2. Continue stitching in a line to form satin stitches.

Kloster blocks

Satin stitches formed into blocks called kloster blocks are the basis for all Hardanger designs, which are geometric in form. They outline the area which will later be cut and withdrawn. Use your thicker thread. How to start and finish kloster blocks is explained on page 33.

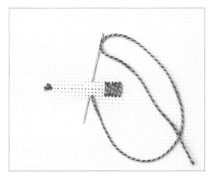

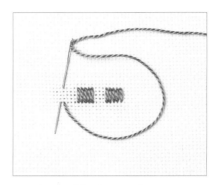

1. A kloster block is formed by working five satin stitches over four threads. Work from right to left and pull the thread so that it sits on the surface without distorting or pulling the background fabric.

2. Kloster blocks can be sewn in a straight line, as shown.

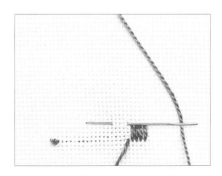

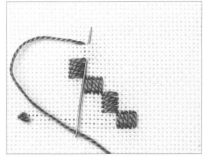

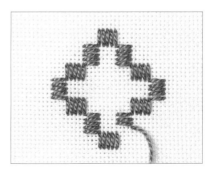

3. Kloster blocks can also be sewn on the diagonal, in this case to form a diamond. On the fifth stitch insert the needle at right angles to the last satin stitch, surfacing four threads to the left. Complete the block. To form the next, come to the front through the same hole as the last satin stitch.

4. Continue to work a diagonal line of kloster blocks. To turn the angle and stitch the second side, bring the thread to the surface at right angles and four threads up from the previous block as shown.

5. Complete the diamond, working clockwise and turning the work as necessary to stitch.

Eight-pointed star in satin stitch

Stars are probably the most commonly used motif throughout traditional Hardanger embroidery and are an important decorative feature of this technique. The dimensions of the stitch may be altered, halved or adapted in order to fit a given space.

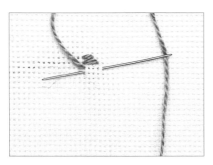
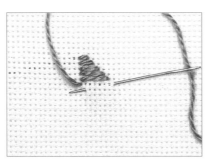
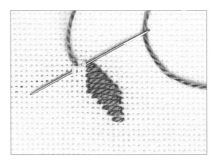

1. Bring your needle to the front two threads down from your centre point and stitch two threads across to the right. Increase the width of the next stitch to go over three threads.

2. Continue to increase the width and number of threads with each stitch on the right-hand side, up to seven, keeping the left-hand side straight.

3. Now decrease the number of threads across back to two, forming the top of the star, this time keeping the right-hand side straight. Take the thread behind and weave through the back of the stitches to the starting point, surfacing ready to begin the next star point as shown.

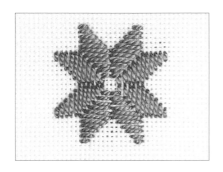

The finished star

Tulip

Adding more stitches to the edges of a star turns it into the tulip motif.

To complete the motif, stitch a mirror image of the first shape and then stitch three more pairs as shown.

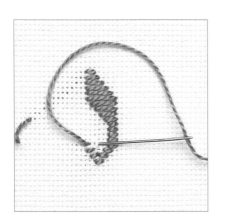

1. Continue from the star point, stacking four more stitches in a straight line over two threads as before. Complete the shape by working three stitches on the diagonal to form the point of a 'v' shape. Work three stitches on the diagonal up the other side of the 'v'. Finish with one stitch over two threads to form the curl.

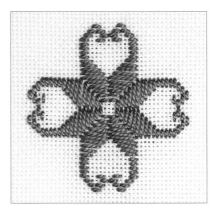

Heart

The heart shape is another recurring motif in Norwegian embroidery. It is often seen on the embroidered square under the sleeveless jacket of the Hardanger folk costume, worked in either beads or stitchery. This small satin stitch heart variation forms an interesting single motif or a decorative border.

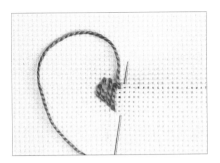 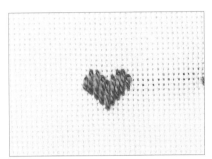

1. Make a first satin stitch over three threads. Next stitch step up one thread and down over five threads. Repeat, keeping level at the top, but going down over six threads. Step down one thread and take a stitch over six threads, repeating once more to form the centre stitch of the heart.

2. Complete the other half of the heart in the same way, working the stitches in reverse order. This stitch may be worked from either direction.

Twisted lattice band

This versatile braid-like decorative stitch is often seen on the edges of bands of traditional Hardanger embroidery. Ribbons or beads add an interesting dimension to the look of this stitch.

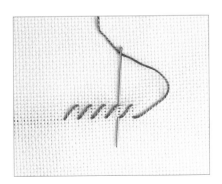 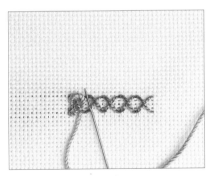

1. Form a line of half crosses over four threads.

2. Complete the crosses on the return journey. Weave another thread under the legs of the crosses and over the intersections, pulling the thread gently as you go.

3. Complete the interlacing on the opposite side, finishing off by taking the thread to the back through the same hole as the first cross stitch.

Pulled thread techniques

Specific pulled thread stitches are a significant feature of Hardanger embroidery, used to echo or accentuate the kloster block shapes. They help to add delicacy to the finished design and are best worked in threads the same colour as your background fabric, as it is important to see the effect created by the pulled stitches. Always use the finer thread for your pulled thread stitches. How to start and finish pulled thread techniques is explained on page 33.

Square eyelets

Small stitches worked around a square are pulled to create a hole in the fabric. This technique is effective when used within a square of kloster blocks or standing alone as part of the overall design.

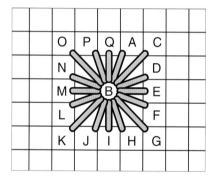

It is important to start the eyelet at A where it is shown in the diagram. The last stitch made will be vertical and so it will fit snugly between the two angled ones either side. This ensures that the finished effect will look even all the way round.

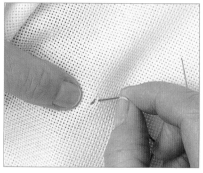

1. Bring the needle to the surface at A, two threads up from the centre and one thread to the right. Stitch back down into the middle (B) over two horizontal threads. Gently pull the sewing thread away from the centre hole before taking the next stitch (C).

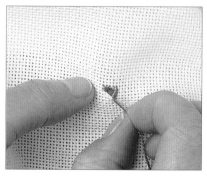

2. Continue working around the square over two threads, following the diagram and pulling away from the centre between each stitch. The fabric count, type of fabric, and how hard you pull will determine the size of the finished hole.

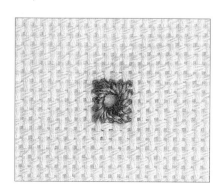

The finished square eyelet

Algerian eyelets on the diagonal

These can be worked around a square, but pulling and working them on the diagonal gives a more open and delicate effect, as fewer stitches are used to form the unit. 'Open' holes on the diagonal are created in solid areas, thereby outlining and lightening the overall effect of a design.

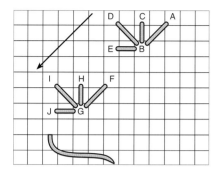

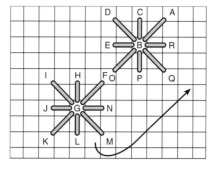

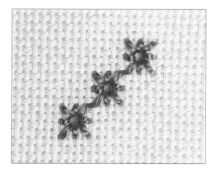

Finished Algerian eyelets on the diagonal

1. Come to the surface at A and down into the centre diagonally over two threads to B. Pull the thread gently away from the centre hole. Proceed round the outline following the lettering CB, DB, EB, FG, HG, IG, JG and pull between each stitch.

2. Turn the work to stitch the return journey. Fill in the other half of the eyelet, pulling away from the centre as before between each stitch. Continue in sequence until the other half of the stitch is completed.

Diagonal eyelets

Diagonal eyelets are extremely useful for incorporating into satin stitch motifs as they are light and open and contrast with the heavier stitchery. I learned the sequence of this stitch whilst on a trip to Hardanger.

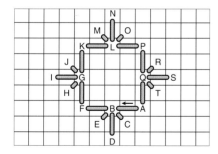

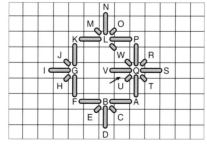

1. Work clockwise round the outer edge of the eyelets starting at A and proceeding as follows: A to B, C to B, D to B, E to B, F to B and back to F; continue as before working F to G and on through to K to G, back to K. Repeat until you reach A to Q. Gently pull the thread away from the centre hole between each stitch.

2. Now reverse the direction of the stitch to work the inside of the eyelet. Proceed U to Q, V to Q, W to Q, and back to W. Carry on as before to complete the diagonal eyelet.

3. Continue to pull the thead gently away from the centre hole after each stitch. Be consistent, or secondary holes appear which detract from the finished effect.

Finished diagonal eyelets

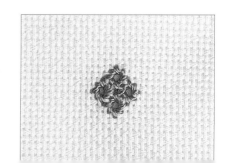

Reversed diagonal faggoting

The slightly raised and open effect created by this diagonal line of pulled threads offsets the kloster blocks. The textural contrast with the heavier surface stitchery also provides an effective way of defining and linking designs. It is preferable to use the same colour thread as the background because the holes created by pulling stitches are the effect, not the threads.

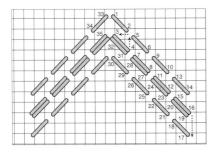

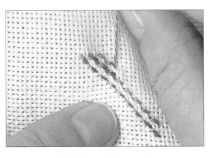

1. Follow the numbering to work the first stitch diagonally over two threads.

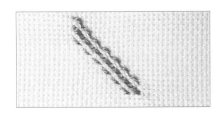

2. The second stitch will form the centre line. Do not pull until the second stitch is made and then pull carefully away from the centre towards the next stitch. Continue to pull every other stitch, holding the stitch as you pull to prevent the fabric twisting.

The finished effect. You can create a mitre with this stitch, or it can be squared off to form a right angle as shown here.

3. To work the other side, turn your work upside down and you will be looking at it in the same position as when you started, which makes it is easier to understand. Repeat the second line as the first and the main holes will appear down the middle line, with secondary holes on the outside.

Four-sided stitch

This useful and decorative technique comprising straight stitches forming a square works as a border or a filling stitch.

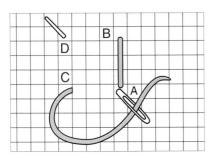

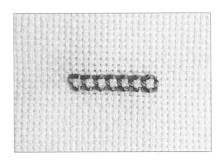

1. Follow the lettering as shown. Bring the needle to the surface at A and down through B, four threads above A, pulling firmly. Continue with the sequence to complete the square.

2. Pull the sewing thread firmly after each stitch is made, but try not to distort the fabric as you pull.

A line of completed four-sided stitch. This stitch may be worked over a different number of threads to change its dimensions and effect.

Hem stitch

This pulled thread stitch for securing a hem (see page 32) or bordering linen is not only decorative, but also very practical.

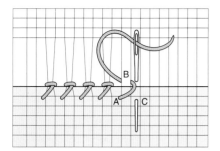

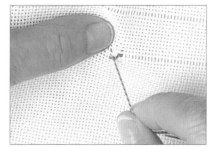

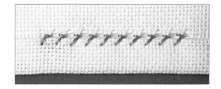

1. Following the diagram, come to the surface at A and collect the required number of fabric threads before completing the stitch, bringing the needle through at C as shown. Two, three or four threads may be gathered up if preferred.

2. Pull the wrapped threads tightly before completing the stitch. If appropriate to the design, one or more threads may be drawn out of the stitching line and hem stitch worked on the opposite side to create an open border beside the hem.

Above: A row of hem stitch completed, showing the hem side. Hems may be folded to the front or the back as you wish. This picture shows one background thread drawn out of the hemming line for ease of sewing. Below: The same row of hem stitch viewed from the other side.

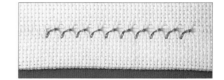

Pin stitch

This 'minimalist' stitch forms small holes between the wrapped bunches of threads giving hems and borders a neat, crisp and uncluttered look. A thread matching the background works best.

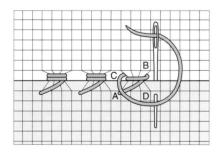

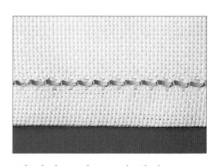

1. Prepare the hem in the usual way. With the wrong side facing you, bring the needle to the surface at A through the hem turnings. Gather up and wrap a cluster of threads (two, three or four) BC. Pull tightly and repeat. Bring the needle between the folded hem at D.

2. Surface with the needle two threads down from the edge of the hem and between the hem and fabric. Continue with the next stitch from this position. With a fine fabric you may prefer to wrap the clusters just once as shown above.

A finished row of pin stitch. The hem is always turned to the back with this stitch. A fabric thread may be withdrawn in the stitching line for ease of sewing and effect.

Edgings

Edgings are always an important element of your embroidery; they define your work with the contrast in texture and are fun to do. Traditionally, pulled thread edgings are worked in thread matching the background fabric, as the decorative effect relies on the holes which appear with the stitching. Adding beads to these traditional techniques creates a sparkling new dimension to your work.

Back stitch picot

Picots are formed with three simple back stitches worked in the fold line of the hem. Using a thicker thread gives a more prominent picot.

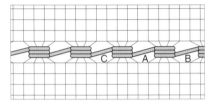

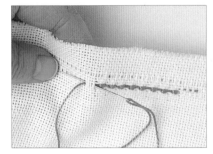

1. Leaving at least twelve threads from the outside edge of the hem, pull out a single thread to create a definite line in which to work the back stitches and form the picots. Come to the front at A and taking a back stitch to B, gather up four threads.

2. Gather up your clusters of four threads as shown. Repeat AB twice more, pulling tightly, ensuring the stitches are lying flat and not piled up on top of each other. Move forward to C and repeat.

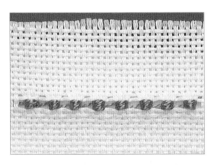

A finished row of back stitch picot. The thickness of thread defines the size of picot: the thicker the thread the more prominent the picot. To turn a corner, work to the end of the line and continue round.

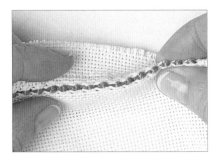

3. Once your line of triple back stitches is complete, finger press the fabric hem back on itself so that the stitches are sitting 'proud' on the top edge. Tack in place if you prefer. You are now ready to complete the hem with the open-sided square edging stitch (see opposite).

Adding beads to back stitch picot

This is an excellent way of adding interest on the edge of your finished pieces. The type of bead you choose, matt or iridescent, will determine the final effect. Use the appropriate needle and thread (e.g. waxed sewing cotton or a monofilament thread) for the size of bead you have chosen.

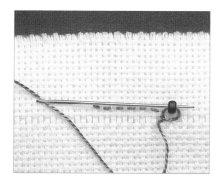

1. Follow the same process as for normal back stitch picot. Take your first back stitch over four threads, come to the surface and thread on the bead before taking the next back stitch. Work the final back stitch by going through the bead for the second time to secure it in position.

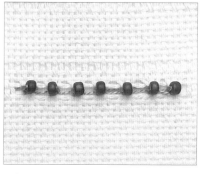

A finished row of back stitch picot with beads. Once the hem is turned over, the beads will sit proud on the edge. This picture shows a thread withdrawn on the edge side – this will make it easier to stitch the open-sided square edging stitch in the right place (see below).

Open-sided square edging stitch

This second stage of the above technique secures the hem and will create an open, lacy effect. Depending on the effect required, a single or double row of this stitch may be worked. A double row will make the hem more durable.

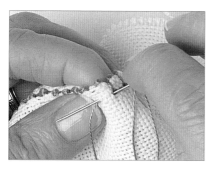

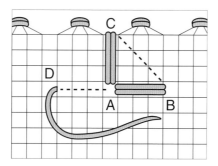

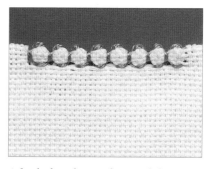

A finished single row of open-sided square edging. To turn, simply mitre and fold the fabric on the corner and continue the edging stitch at right angles, proceeding round the corner.

1. Working through the two layers of fabric and lined up with the picots, come to the front at A, taking a back stitch over four threads to B. Repeat the process. Follow the diagram to C and back down over four threads. Repeat. Pull firmly after each stitch to produce small holes at the base of the stitch. To turn a corner, stitch the work to within 2.5cm (1in) and mitre the corner fabric. Turn in the folds to the back and tack loosely in place. Complete the open-sided square edging stitch to the end of the line, working straight over the mitred corner and keeping the counting correct. Work the first stitch round the corner at right angles to the last stitch, (over the mitre again) and you will find that it fits in to make a perfect turn.

Cutting

Nothing should be cut until all surface embellishment has been completed and all the kloster blocks have outlined the designs. Withdrawing the threads for embellishment is not as intimidating as it first appears, simply follow some basic rules.

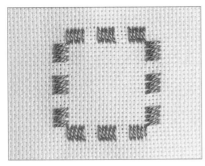

1. A square shape outlined with kloster blocks and ready for cutting. Always cut against the stitched side of a kloster block, never at the open end, and only cut four threads.

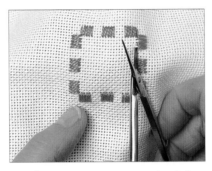

2. Place your scissors to the left-hand side of the block. Collect the four threads on your scissor blades to check you have the right number and cut all at the same time, close against the blocks.

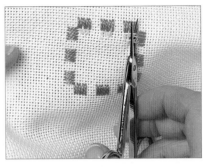

3. Cut against all the appropriate blocks on one side of the design before turning to cut the next side. Work round your shape systematically until all the opposite threads are cut.

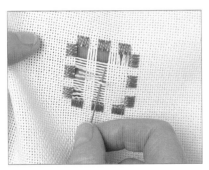

4. Once all the threads are cut, carefully loosen them with a needle and withdraw. Tweezers can be quite useful for this.

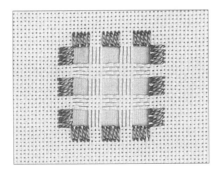

The finished cut square. If you cut a thread by mistake, leave it in place. Pull out a background thread from the side of the work. Follow exactly the mesh weave and darn your new thread into position ready for needleweaving. Needleweave the new and cut threads together.

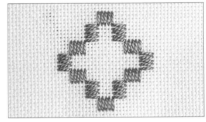

Above: A diamond shape outlined with kloster blocks ready for cutting. Below: The diamond shape cut and mounted on pink fabric. Once the work is washed, the small 'whiskers' left by the cutting should disappear and be absorbed into the blocks if they have been cut closely enough. Very careful trimming will get rid of persistent visible 'whiskers'.

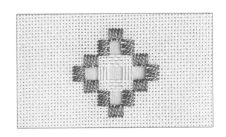

Needleweaving

Needleweaving uses the finer thread and forms the basis of all the open and decorative filling stitches. It is important for needleweaving to be even, tightly woven and straight, otherwise your filling stitches will look untidy. The number of needlewoven stitches to each bar depends on the fabric count. Once you have established the number on the first bar, the remaining bars should number the same to achieve uniformity throughout the design. Picots and knots may be worked on needlewoven bars.

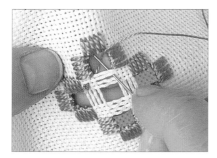

1. To start, anchor the thread through the back of the kloster blocks, or follow the method shown above. With a waste knot on the surface, take your thread from underneath across the open square. Place your needle in the middle of the bar threads, with the tip just over the thread.

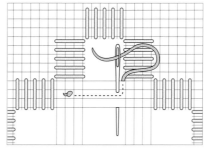

2. 'Flick' or 'cast' your needle over the thread so that the thread is now lying between the two middle threads of the bar, and the tip of the needle is facing you underneath the two nearest threads. The needle is now in the right position for you to start needleweaving.

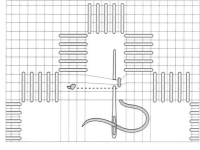

3. There will be an extra thread in this first bar to be included in the needleweaving. Once the end of the bar is reached, cut off the surface knot. This method of starting ensures that there are not so many loose ends being worked through the kloster blocks.

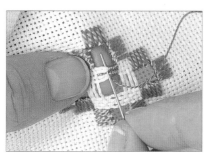

4. Bars are woven in a figure of eight. Take your needle down in between the pairs of threads, over two threads and back down into the middle. Continue weaving under and over two threads at a time until the bar is completed. Pull your stitches tightly to accomplish a neat, even tension.

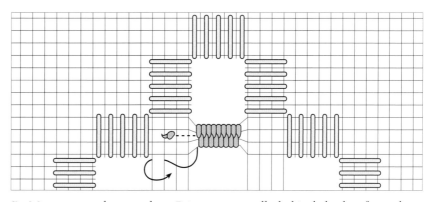

5. Move on to the next bar. Bring your needle behind the bar from the far side and down into the bar on the next 'step'. Continue needleweaving as shown by the arrow. At the end of the first diagonal row of bars, finish off the thread and re-start at the top right of the next row of steps to be worked. Working your needleweaving consistently diagonally across the design in steps from top right to left will ensure that the decorative fillings and crossed lines are all worked in the same way.

Wrapping

Wrapped bars look thinner and are harder to keep even and straight, but they are needed as the basis for some of the other decorative fillings such as Greek Cross. Knots or picots cannot be worked on wrapped bars, but the threads on the bars may be divided and wrapped. As for needleweaving, the finer thread is used.

Wrapping may be worked horizontally or vertically and sometimes you may have to reverse the wrapping to suit a particular filling or design, but whichever method you use, try to be consistent.

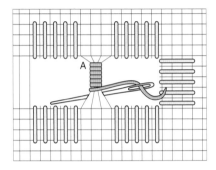

It is important to wrap without overlapping any of the stitches and to control the tension by holding each stitch as you work it. Secure a new thread in the kloster blocks and bring it to the surface from underneath the bar and wrap as shown. Finish the thread by taking it to the back and working through the kloster blocks with small back stitches as usual.

When single bars are wrapped in a line, take care, as you move from bar to bar through the back of kloster blocks, to keep straight lines and the correct wrapping method. It may be necessary to take the thread back through a kloster block which is behind the progression forwards in order to secure it. Simply take a loop stitch over a thread in the block and travel back the way you want to go, surfacing ready to start a new bar.

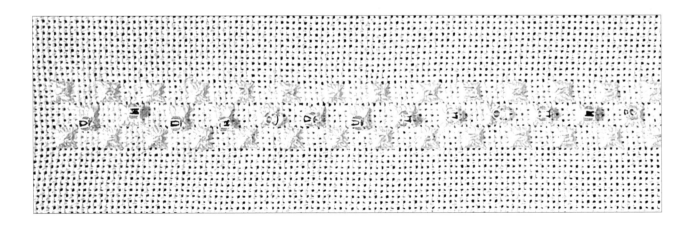

Fillings

Decorative fillings are an integral part of the needleweaving technique and soften the hard and structured cut and drawn grid lines with their delicate and lacy effects.

There is a wonderful variety of fillings, from simple to complex. The fillings in this book will work well with beads or stand on their own as traditional fillings. Most of the fillings in the projects are interchangeable so that you can choose whichever you like.

Introducing beads into decorative fillings is simply an extension of the basic traditional method of working the stitches, but the beads should be connected as part of the filling and not added as an afterthought. Where you place the beads as you work the stitch will alter the appearance of the filling. The beads should not be twisted in any way but left to follow the lines as the filling is formed. Using matt or iridescent beads is a personal choice and will create a different appearance. Varying the size of the beads will also change the final effect and is worth experimenting with as the results can be very unusual and interesting.

Dove's eye filling

This delightful open, lacy filling is probably the best known of all fillings and may be used with either wrapped or woven bars. There are many variations developed from this basic filling.

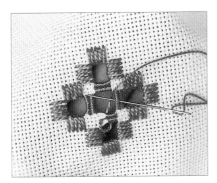

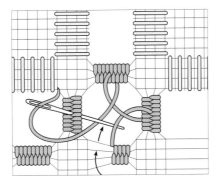

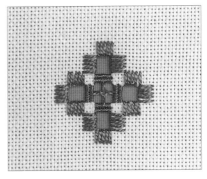

1. Needleweave (wrap or complete) three and a half bars or sides of any square in which the Dove's eye is going to be worked. Bring the thread up into the middle of the square. Stitch down into the centre of the needlewoven bar to the right and make the first buttonhole 'loop' as shown, taking the needle over the thread to form the stitch.

2. Adjust the size of the loop and shape and continue in this way round the square creating the loops which form the filling. To complete the fourth buttonhole loop, take the needle and thread behind the first loop formed, pull through to the front and adjust the shape before needleweaving the rest of the bar and continuing the design if applicable.

The finished dove's eye filling. Dove's eyes may be worked either clockwise or anticlockwise, whichever is appropriate, but all four loops of the filling should have the threads crossing in the same direction. Try to form a small, neat hole in the middle of the shape as seen in the picture.

Dove's eye filling with beads at the points

Placing and working the beads in the following manner will accentuate the little 'eye' in the middle of the filling. Larger beads may be used to crowd into the space for texture.

1. Needleweave as before to bring your thread into the middle of the square. Find a needle to fit the thread and bead. Thread two beads on to the thread and form the first loop. Bring your needle over the loop ready to progress to the next, but first go through the top bead, leaving the first bead loose on the thread as shown. Pull the thread through, thread

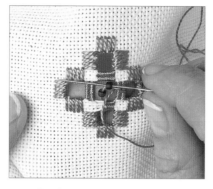

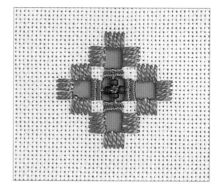

The finished dove's eye filling with beads at the points

on another bead and repeat the process to the final stitch. Come up behind the first loop as before and take the needle through that first (now last) bead before continuing with the needleweaving to finish the bar.

Dove's eye filling with beads on the loops

In this filling the beads sit on the loops between each stitch and form an attractive floret shape. Using matt beads in the same colour as the background stitching is particularly effective.

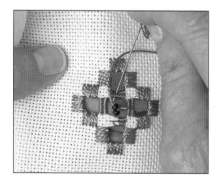

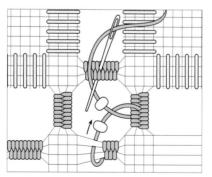

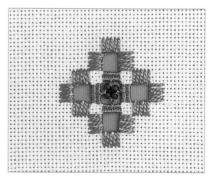

1. Needleweave as before to bring your thread into the middle of the square. This time thread only one bead on to the thread before forming the first loop. Once the loop has been formed, thread on the next bead and proceed as usual round the square. Finish off as normal.

2. The beads may have to be adjusted on the loops before the filling stitch is completed.

The finished dove's eye filling with beads on the loops. In this instance the needle does not go through any of the beads.

Dove's eyes with wrapped bars

The different shaped motif provides an opportunity to work a variation of dove's eye filling, in which beads could be included following the same principles as already shown.

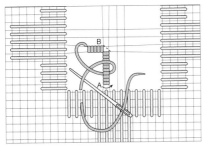

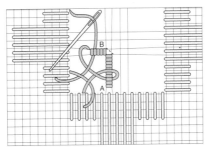

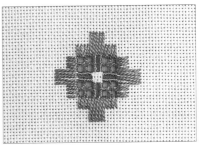

1. Secure your thread in the kloster blocks and surface at A. Wrap two threads on the first bar in the direction of the small arrow. Complete the bar, pass under the intersection to come up at B on the second bar of two threads. Continue wrapping until you reach the centre of the bar and then form the dove's eye as shown.

2. Complete the rest of the dove's eye filling in the correct progression to form the last two loops. Adjust the loops as necessary. Continue to wrap to the end of the bar. Take a back stitch under the second and third bars to pull them tightly together before moving foward to wrap bar 3 in the same way.

The finished dove's eye with wrapped bars. A small central eyelet may be included and worked before the final bar of the motif is completed.

Square filet filling

This delicate squared filling stitch may be worked on either woven or wrapped bars, and when worked over larger areas, a secondary pattern appears, effectively outlining the unfilled squares with a 'halo'.

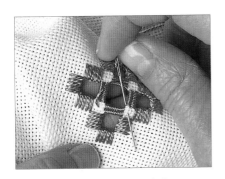

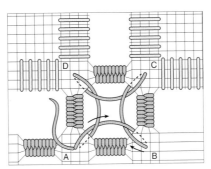

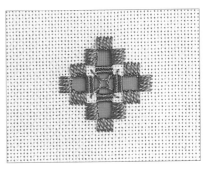

1. Complete all sides of the square. Bring your thread to the front at A and take a stitch into the first corner from underneath to surface at B, forming the first loop. Adjust and take your thread underneath the loop AB. Proceed to the next corner and repeat.

Make the last stitch by taking the thread over the loop AB. If working more than one filling, bring the thread up again at A and take a very small back stitch diagonally under the loop, pull tightly to hide it and then proceed with your next bar of needleweaving.

The finished square filet filling. This may be worked clockwise or anticlockwise but be consistent to ensure that the threads all cross in the same direction as the stitch is being formed.

Square filet filling with beads

The effect of the secondary pattern is changed with the inclusion of beads in this filling, making the square look as if it has textured knots in each corner.

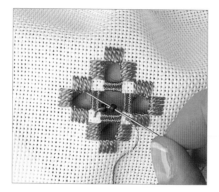
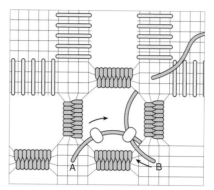
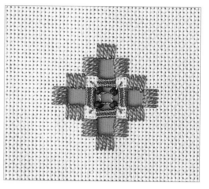

1. Come to the front in the corner as before but thread two beads on to the needle before coming from behind to surface at B. Take the needle through the nearest bead, leaving one loose on the loop. Adjust the length of the loop.

2. Continue round the square in this way until the last loop. Take the needle through the first (now the last) bead and work as before to complete the filling, or move on to do more.

The finished square filet filling with beads

Greek cross

As a filling in a single motif, this makes a strong and definite 'statement' and is fun to do. Different effects are achieved when Greek cross is used to fill larger areas or worked on the diagonal.

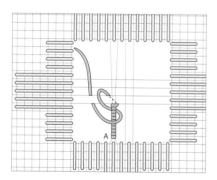
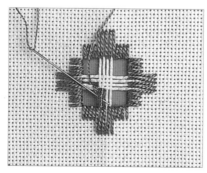

1. Secure the thread in the kloster blocks and come to the front at A to wrap (clockwise) two threads of the bar. Following the diagram, wrap to the end of the bar. Passing the thread underneath the centre intersection, work a figure of eight over these two threads and the bar already wrapped.

2. Pull the first stitches tightly and loosen gradually to form the fan shape. When the fan is the size you require, continue to wrap the rest of the bar. Remember to work the same number of wraps in each part of the stitch formation.

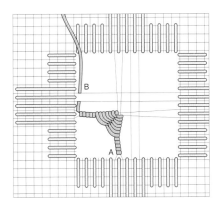

3. At the end of the wrapped bar, take the needle underneath the next section of two threads. At this stage one stitch may be worked over the two separate bars to pull them together at the tips. Now repeat the process of wrapping to complete the whole Greek cross filling.

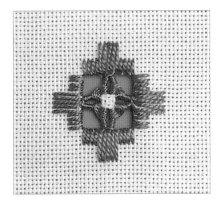

The finished Greek cross

Divided branch stitch

This filling works well in a single motif to break up and lighten the definite lines of the needlewoven bars.

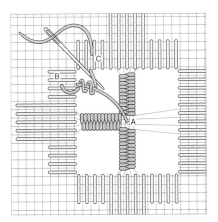

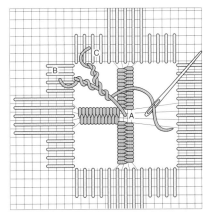

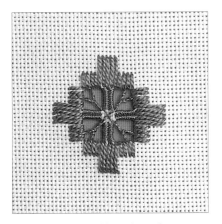

The finished divided branch stitch. Picots could be added to the woven bars for extra decoration (see page 30).

1. Anchor your thread in the kloster blocks or as for starting to needleweave (page 23). Start at the bottom of the motif and weave the two vertical middle bars. Move behind the blocks to surface and weave the left-hand horizontal bar. On completing this bar, come to the front at A in the middle of the intersection. Bring the needle up from behind at B, two threads in from the end of the kloster block motif. Go underneath the loop and make two or three wraps round the thread as shown.

2. Repeat the process to come up on the next side of the motif at C. Repeat the twists on this branch and move on to wrap the main thread. Come back up from underneath in the middle at A, ready to start the branch in the next open square. Work all four branches in this way. After the final branch is completed, come to the front and take a small diagonal back stitch on the intersection, pull tightly to hide and needleweave the last bar in the usual way.

Divided branch stitch with beads

Placing the bead at the bottom of the single branch will create a focal point in the middle of the square and soften the hard lines of the bars, to give a star-like effect.

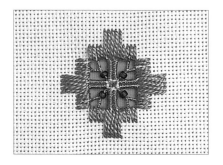

To incorporate a bead in this filling, simply thread on the bead once you have come to the front at A. Work the rest of the stitch as described on page 29. After your final twist on the main branch, go through the bead once more before surfacing from behind at A again. Work all four branches in this way.

Picot knots

Small knots formed on the sides of bars are probably the most useful of all filling stitches as they soften the lines of woven bars or, within a single square, help give the impression of rounded corners.

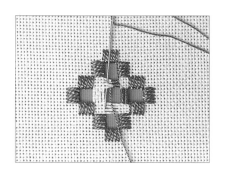

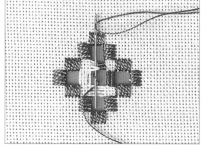

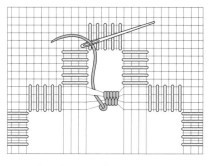

1. Weave to the middle of the bar. Follow the direction of the last stitch and turn the needle tip towards the loose thread as shown.

2. Take the thread under the needle and wrap it over the tip. Gently pull the needle and thread through the bar and loop. Pull tightly to form a small knot. You can place a needle in the loop as it is pulled to form an open picot if you wish.

3. Take the needle into the middle of the bar to continue weaving, but first pull the thread across to the unwoven end before bringing it straight back in line. Hold the knot as you pull firmly to anchor it in position. Continue to weave as usual.

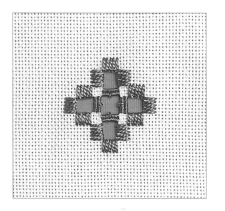

The finished picot knots. Small knots are more elegant than large ones. Try to make them all look the same and place them evenly in the middle of each bar. Knots may be worked on either side of bars, if appropriate.

Borders

Many of the surface stitches used in Hardanger may be turned into interesting borders, from the simple to the more complex. There are various bands and borders on the Hardanger sampler on page 45 and throughout the book, giving you the opportunity to create your own combination of ideas. Innovative borders can be used to make an interesting traditional band sampler like those of the seventeenth century.

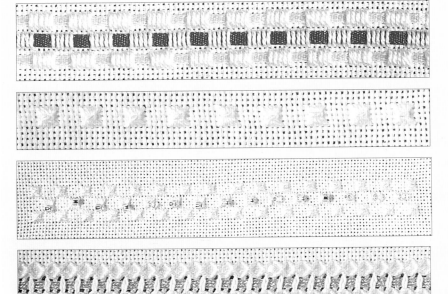

Alternating lines of kloster blocks with satin ribbon threaded through the middle

Wrapped kloster blocks to give a textural outline

Alternating lines of wrapped kloster blocks. The middle line is wrapped with a silver bead on the thread.

Withdrawn threads, hem-stitched on both sides with twisted lattice band over the top and ribbon threaded through the clusters

Two 'petals' of the satin stitch star reversed and formed into a diamond motif. This is then filled with Algerian eyelets or reversed diagonal faggoting and an eyelet. Motifs joined together would form an interesting border pattern.

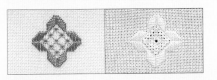

Algerian eyelets forming a diamond shape to enclose satin stitch diamonds

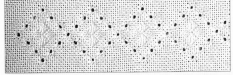

Mitred reversed diagonal faggoting forming a zigzag to divide satin stitch heart motifs

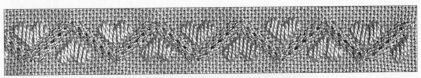

Mitred reversed diagonal faggoting, beaded down the centre line and formed into a diamond shape with diagonal eyelets in the centre and satin stitch heart motifs

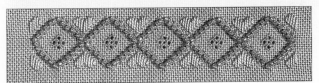

How to Start

Preparing your fabric

Carefully iron your fabric and if the edges are not straight, pull out a thread and cut straight along this line. Oversew the fabric edges to prevent fraying.

To find the centre of your fabric, fold it in half and finger-crease the fold. Fold in half in the opposite direction and repeat the process to find the centre point. As a general rule, tack in the horizontal and vertical lines using pastel coloured thread. Instructions with the projects will clarify which lines to tack in for individual pieces. If you have difficulty with the counting, you could grid up the whole piece in multiples of twelve or to suit your needs.

Put your different balls of pearl cotton into small grip closure plastic bags with just a tail of thread coming out of the top to keep them clean and controllable, and keep your Hardanger in a pillowcase or protective bag when you are not sewing.

Hems

Hems may be finished off in a variety of ways, but should be relevant to the project being undertaken. Decorative hem ideas are given earlier in the book, but sometimes a simple folded hem is enough.

Leave at least a 5cm (2in) hem allowance depending on the fabric count, and if in doubt, be more generous. Whitework hems may be sewn to the front or the back as preferred. With the hem to the front there will be a ridge on the stitching line. Sometimes a thread may be withdrawn on the stitching line for a more open hem effect.

To achieve a good mitred corner, prepare your hem with tacking guide lines. Decide how many threads deep your hem will be and leave at least three times the number before tacking your actual stitching line. Count the number of threads to the hem edge and tack a line of stitching on the fold line. Count the same number of threads again for the back of the hem and tack the bottom fold line. Trim the excess threads to one less than your hem so that it will fold up into the allowance and does not curl over. This will make three lines of tacking.

To mitre the corners, pull over the corner until the centre point of the longest side sits level with the tacking on the hem edge. Trim excess fabric from the right-angled triangle which has now been created. Fold in the hem on your tacking lines until it meets on the diagonal at the corner. Tack in place before invisibly stitching the mitres together. Your hem is now prepared for stitching.

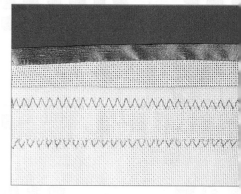

Different ways of preparing your fabric and neatening your edges: binding with fabric, a three step zigzag hem and a three step zigzag oversewn edge.

Threading your needle

This is a simple method of threading a needle with a single thread and will prevent you having to lick or bite the end in desperation. Hold the sewing thread tightly over your forefinger and with your other hand holding the needle, rub the eye over the thread. At the same time slowly turn your finger away from your body and a small loop of thread will pop through the eye of the needle ready to be pulled through completely.

Give this method a chance the first time you do it by using a needle with the eye the same size or slightly wider than your thread.

Starting and finishing

Kloster blocks

Begin with an 'away' waste knot on the surface 7.5cm (3in) to the side of your first stitch. Always start a new thread at the beginning of a block and not in the middle as the difference between the already used and new thread is sometimes noticeable.

To finish off, go through to the back of the work, slipping the needle through the back of the kloster blocks. Come up in the middle of the second block and take a back stitch over the centre stitch. Hold the stitch as you pull tightly to set it into position. Repeat this in the next block before taking the thread through one more block to ensure it is secure. Once all the blocks are finished, cut the knot of your starting thread, rethread and take this underneath to weave through the back of the blocks as already described.

Wherever possible, try to start and finish in different directions to avoid bulk. When you are working blocks in a straight line, and if you feel confident about your counting, to save the bulk on the back you may start your thread in a different way. Come to the front with your sewing thread twenty fabric threads away from the starting point of the first kloster block and up two threads into the middle line. Weave over, under, over and under the nearest single threads and take a neat and tightly formed back stitch over the last. With the needle to the back, go behind the next four threads. Come to the surface and repeat the above process twice more before coming up at the right point to start your first kloster block. Your first three kloster blocks will cover all the weaving and back stitches and there will be a single, flat line at the back between the blocks.

Pulled thread techniques

Rules for starting and finishing the pulled thread stitches will have to be flexible depending on where the stitches will be placed. Generally, start with an 'away' waste knot to work in once the stitch has been completed. To finish off the sewing thread, work through the back of the stitches already formed, taking the occasional back stitch to secure the thread. Make sure your thread is not visible on the surface. When eyelets are placed apart, it is best to start and finish in the individual unit and not take a long thread on the back linked to the next eyelet.

Design

Mediaeval tile designs have been my source of inspiration for the embroideries in this book. As you work through the book, you will see how the design ideas are linked and expanded, with potential for further development. You do not have to look far for inspiration when designing for Hardanger – the mosaic tile floors of buildings, churches and cathedrals provide an open-ended source of geometric pattern from which to start. A simple divided square tile pattern, found around the world, has become the basis for the projects in this book.

Straightforward design principles will help you to create your own ideas. From a modest geometric shape all sorts of designs can be created as you explore the concept.

Sketch or draw the basic outlines to your chosen geometric shape.

Form the shape and interpret your lines in kloster blocks on squared paper using quick and simple strokes, each square to represent a complete block. Add more blocks to the shape for a larger outline.

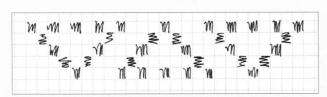

The shapes may be reversed, spaced or mirror imaged and developed to form a border or more complicated designs.

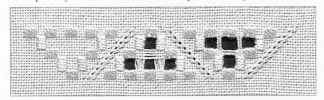

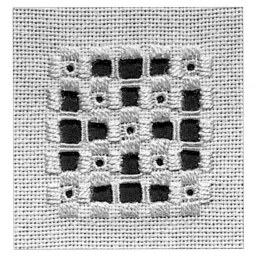

An embroidered interpretation of the original sketch

Transfer painting fabrics

Fabric and threads should not be washed until the Hardanger is completed, because the fibres shrink and close together, so transfer painting is the ideal medium for creating your own background for a specific colour scheme or project. There will be a few surprises, as every fabric reacts differently to the paint or paper used, the temperature of the iron and the length of time it is heated. Transfer paints are for fabrics with a synthetic content, but if you know what your fabric consists of and follow the manufacturers' instructions, you will have some exciting results on which to embroider. You could bend the rules and experiment on different fabrics to see what results you achieve. As this is a surface painting technique and not a dyeing process, beware of pale specks when the threads are cut and withdrawn. Re-printing with the paper or using water-based crayons or even fine felt tips will help colour those small areas.

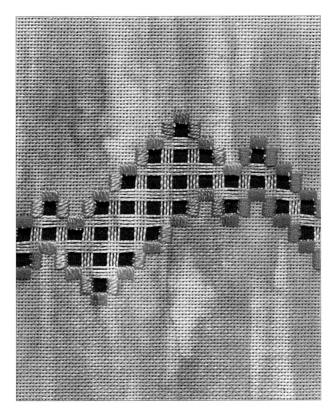

This experimental sample was painted on a cotton mix fabric. The fabric painting was deliberately worked in definite lines of contrasting colours as I wanted to have a range of threads which I could use to achieve sharp contrasts in colour and tone, instead of resorting to multicoloured threads, which often 'play safe' in a middle range of tones. This gave me the opportunity to stitch Hardanger in a 'free' way, using and following the colours to help determine the shape of the design.

Washing finished work

Hand wash your finished piece carefully using a mild soap powder or liquid. Rinse it well and dry flat on a towel, stretching the piece carefully back into its original shape. While it is still slightly damp, iron and press it face down into the towel so as not to flatten the stitching.

Using a chart

Each line represents one thread of fabric.

For the larger projects a quarter or repeat chart is given, but the whole chart will be shown for the smaller projects. The centre lines are signified by small dark arrows on the edges of the chart. The lettering on the charts denotes where to start and should be used in conjunction with the text for clarification. The number of stitches shown on each bar is an average number, just to denote the procedure.

The keys accompanying the charts indicate the stitches and threads to use.

The chart for the embroidery shown opposite. Start from the point marked A.

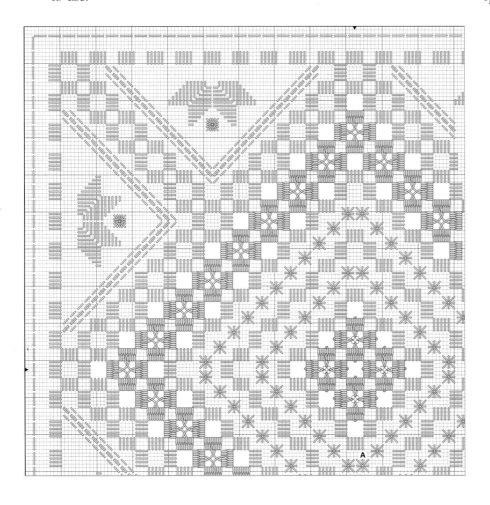

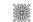

Square eyelets
White coton perle No. 12

Kloster blocks
White coton perle No. 8

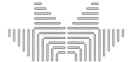

Satin stitch star
White coton perle No. 8

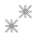

Algerian eyelets
White coton perle No. 12 with blending filament

Reversed diagonal faggoting
White coton perle No. 12

Pin stitch
White coton perle No. 12 with blending filament

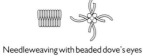

Needleweaving with beaded dove's eyes
White coton perle No. 12

Needleweaving with dove's eyes
White coton perle No. 12

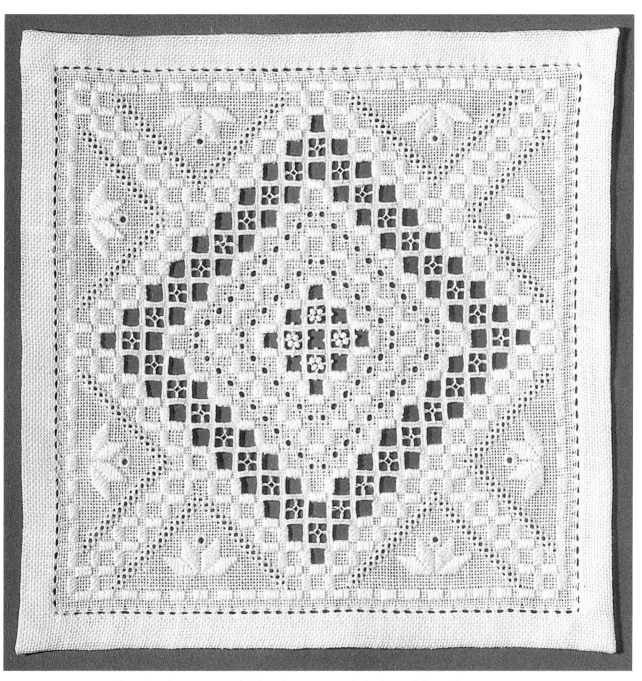

This embroidery was expanded from the asymmetrical tile design of the smaller mat on page 47. By reversing and putting four 'tiles' together I have formed a tessellated design to make into a mat. This could be developed further by repeating and adding this design to each side of the square. In this manner it would go on to form a spectacular all-over design for a table cloth. Alternatively the design could be added repeatedly to only two sides of the square, forming a tray cloth or runner. All the fillings could be changed to suit your own preferences.

Projects

The projects featured here will give you the opportunity to start from the basics and work through to the more advanced techniques. If you prefer, you can work the projects in traditional Hardanger stitches and fillings and ignore the addition of beads – the effects will still look beautiful. Experimenting with transfer paints and beaded fillings is a contemporary aspect to consider. Not all the decorative fillings in the book are worked in the accepted manner of traditional Hardanger as I have tried other ideas such as wrapping, tied ribbon or little buttons. If you already know about Hardanger, develop the designs further to suit yourself, insert your own favourite filling stitches instead of the ones suggested, and do not be afraid to try out your own ideas.

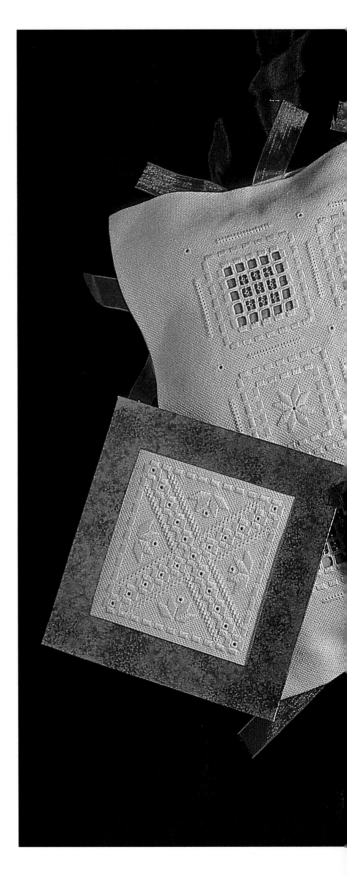

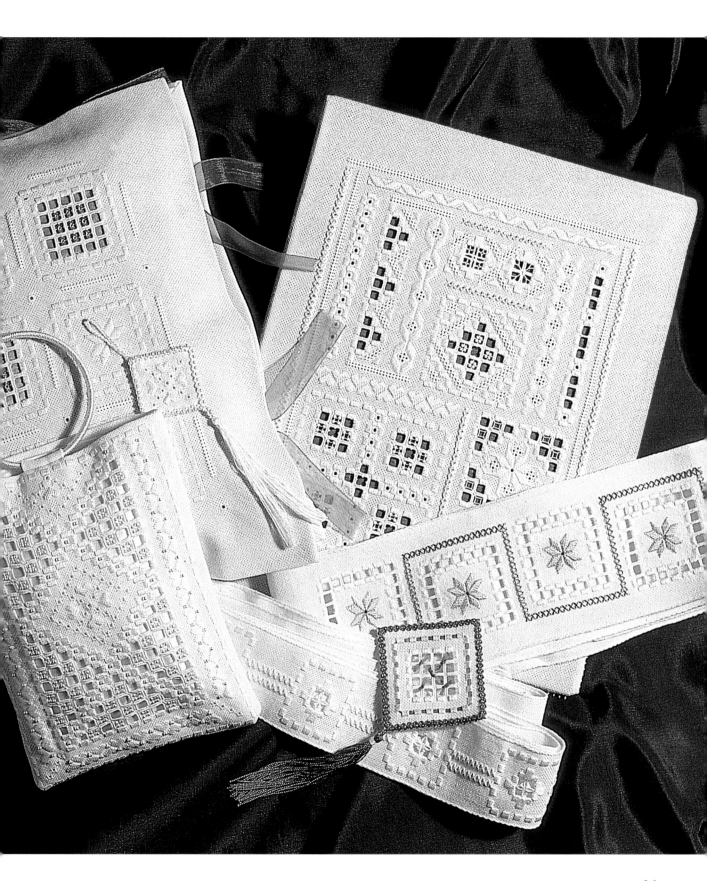

Greetings Card

The simple 'tile' design for this small piece of embroidery to make a greetings card inset introduces you to surface stitchery, using kloster blocks, half eight-pointed stars, square eyelets and reversed diagonal faggoting. There is no cutting and withdrawal of threads, which makes this an excellent starting point for understanding how kloster blocks form the basic outline for Hardanger designs. The finished size of the inset is approximately 8.7cm (3⅜in) square.

This design could be interpreted with coloured threads of your choice or metallics.

If you use a higher thread count, the design will come out slightly smaller and you may like to work an extra decorative outlining border round the finished piece to fill in the space between the design and the aperture card.

The pink and purple cards on page 43 are developments of the design and gives you the chance to cut and withdraw threads to form a simple open design of needleweaving or a larger grid on which to work some ornate filling stitches, with or without beads.

- Follow the chart on page 42. Prepare the fabric as described on page 32.

- Using coton perle No. 8, start the first kloster block (see page 13) at the bottom right-hand corner, 38mm (1½in) in from either edge, coming to the surface at A.

- Work clockwise to form a square of eleven outlining kloster blocks on each side. Turn the work as you go to make sewing easier.

- Stitch the blocks on the diagonal line starting at B. Turn the work upside down to form the other side. Repeat the procedure to make the other diagonal line.

- Following the chart, stitch the half eight-pointed stars in satin stitch (see page 14).

- Changing to coton perle No. 12, fill the diagonal lines of kloster blocks with square eyelets, pulling the last stitch away from the centre hole each time. Progress systematically up the line, working through the back of the kloster blocks to begin each eyelet at the same starting point. Add an eyelet to the top of each half star.

You will need

15cm (6in) square of white evenweave fabric, 25 threads to the inch or similar

1 ball of coton perle No. 8 white

1 ball of coton perle No. 12 white

Blunt-ended tapestry needle, size 24/26

Aperture card 9.5cm (3 ¾in) square

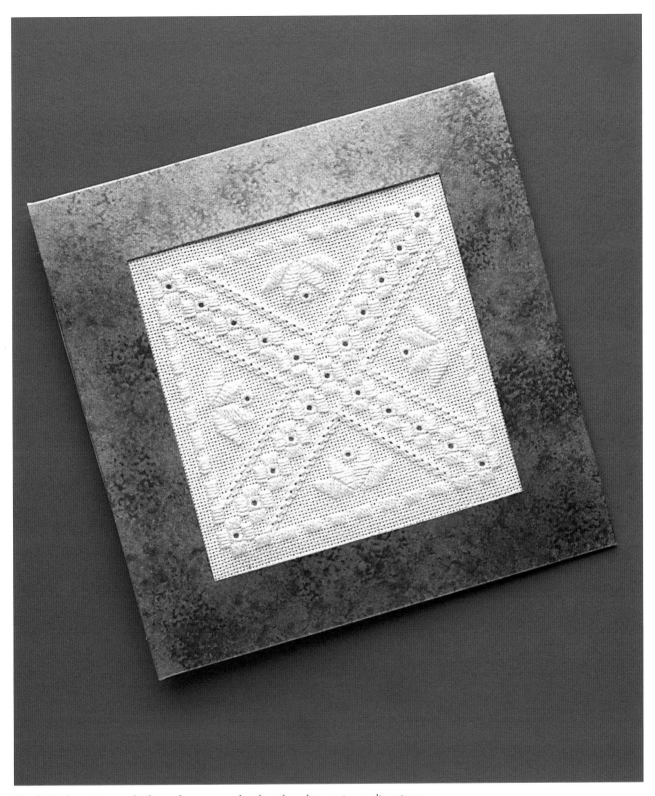

The finished greetings card. The card was sponged with pink and turquoise acrylic paint to create extra interest.

- Commence the reversed diagonal faggoting (see page 18) at the centre point. Stitch down one side and turn the work to sew the other side and complete the open effect. Repeat the process to finish the other half of the V shape.

- Wash and press the work carefully as directed on page 35.

- To insert the embroidery in the aperture card, unfold the card completely and stick double-sided tape on the inside, around the square opening, close to the edge. Place the card centrally on top of the completed embroidery. Stretch the embroidery slightly to make it taut, and stick the card down. Use spray adhesive or use more of the double-sided tape to stick down the right-hand fold of the card, hiding the back of the embroidery.

The chart for the Greetings Card embroidery on page 40

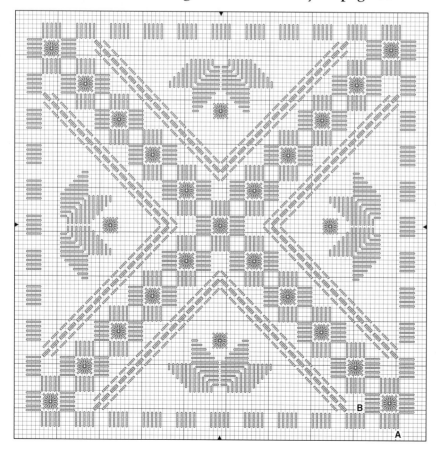

Kloster blocks
Coton perle No. 8

Satin stitch star
Coton perle No. 8

Square eyelet
Coton perle No. 12

Reversed diagonal faggoting
Coton perle No. 12

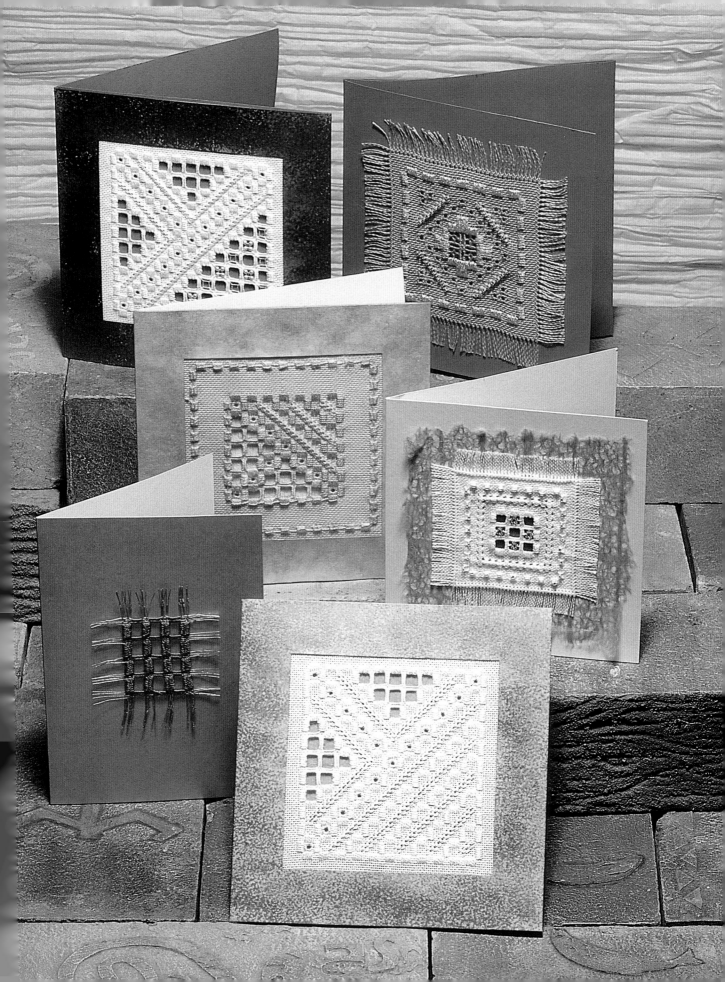

Sampler

This interesting and individual asymmetrical sampler, based on bands of stitch combinations and different sized 'tiles', allows you to practise and enjoy some of the ideas used in this book. It is worked in crisp white cotton with glistening blending filament. White matt beads are added as part of the decorative fillings, to match the cotton and emphasise the effect. The sampler is designed for you to stitch as shown, or interpret with your own ideas and knowledge. Using a different sized fabric count will alter the final measurements and is a matter of personal preference. Fillings may be worked with or without beads and the whole design could be sewn in threads of your own choice.

Enlarge the chart on page 46 on a photocopier.

- Prepare the fabric as described on page 32 and tack in the centre vertical guide line.

- Establish the design by working the largest square with sides formed by eleven kloster blocks. Stitch the units in order as numbered 1 to 20 on the chart on page 46.

- Using coton perle No 8, surface at A, 110 threads or approximately 10cm (4in) down from the centre point and six threads to the right to start square no. 1. Turn the work when necessary. Complete all the inside lines of kloster blocks.

- Line up square no. 2 as shown, twelve threads away from square no. 1, and starting at B, work clockwise to complete a seven kloster block sided square. Fill in with the diagonal lines of kloster blocks.

- Line up and work square no. 3 to the same size and in the same manner, stitching all the blocks to complete the design as shown.

- Stitch the straight lines of kloster blocks numbered 4, 5 and 6, and triangle shapes 7, followed by the motifs 8, 9 and 10.

- Complete the twisted lattice bands numbered 11, 12, 13, and the heart and star band variations 16, 17 and 18.

- Work the top and bottom star bands numbered 19 and 20.

- Change to coton perle No. 12, include the blending filament in the needle and follow the chart to complete all the pulled thread techniques: square and diamond eyelets, reversed diagonal faggoting and single bands of four-sided stitches over two threads both inside the design and bordering the pattern.

Opposite

The finished asymmetrical sampler, size 18 x 24cm (7 x 9½in), shows most of the surface stitchery and decorative fillings demonstrated in this book. Glistening blending filament and silver-lined beads lift the design, and matt white beads complement the stitchery.

This design is the same size as the book and you could turn it into a beautiful book cover. Repeats and mirror images of the design would also make an interesting table runner for those who like a challenge!

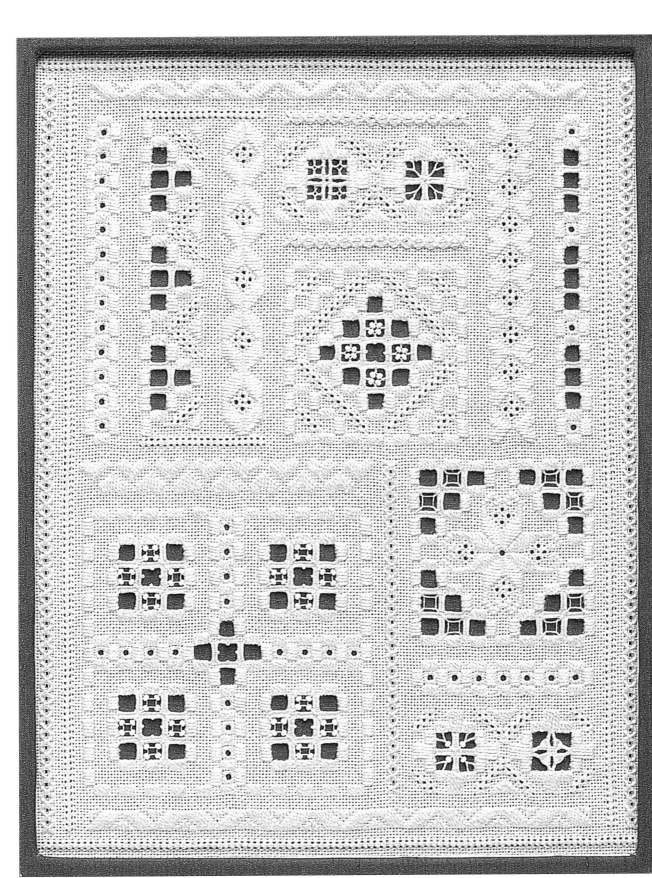

45

The chart for the Sampler embroidery on page 44

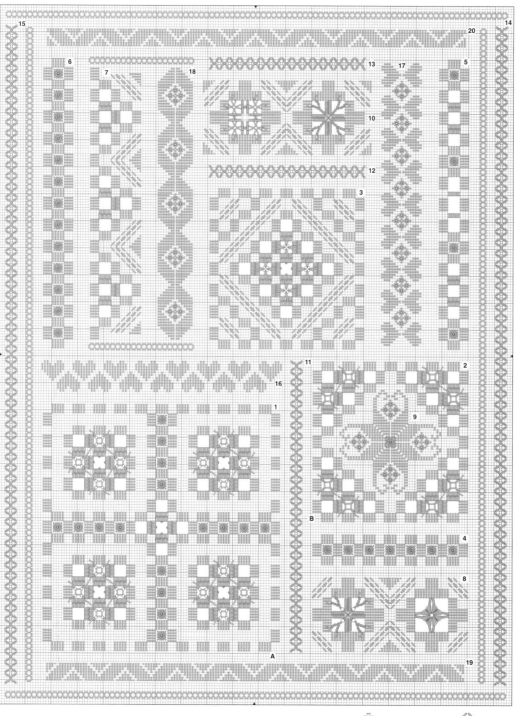

Kloster blocks
Coton perle No. 8

Satin stitch stars, border and tulips
Coton perle No. 8

Twisted lattice band with beads
Coton perle No. 8

Satin stitch triangles
Coton perle No. 8

Satin stitch hearts
Coton perle No. 8

Kloster block outline
Coton perle No. 8

Needleweaving
Coton perle No. 12

Dove's eyes with wrapped bars
Coton perle No. 12

Divided branches with
needleweaving and with beads
Coton perle No. 12

Greek cross filling
Coton perle No. 12

Four-sided stitch over 2 threads
Coton perle No. 12 & blending
filament

Needleweaving &
dove's eye with beads
Coton perle No. 12

Needleweaving & square filet
filling with/without beads
Coton perle No. 12

Needleweaving with
picot knots
Coton perle No. 12

Eyelets, tulip & diagonal eyelets
Coton perle No. 12 &
blending filament

Reversed diagonal faggoting
Coton perle No. 12 &
blending filament

- Using the coton perle No. 8, work the two outer lines of twisted lattice band 14 and 15.

- Continuing with coton perle No. 12 (but no blending filament), cut the design as given in the chart, one unit at a time. Needleweave (see page 23) and incorporate beads, as shown in the pages on fillings on pages 26–27.

- Fill all the twisted lattice bands with the silver-lined beads. Sew them on with back stitch. Using a needle and thread which will go through the bead, come to the surface, thread on a bead and take a back stitch over two threads in the middle of each cross. Progress forward to the next cross and repeat.

- Wash and press the work carefully (see page 35), especially as there are beads in the piece. Take your finished piece to be framed by a professional, unless you prefer to lace and complete the work yourself. Coloured fabric or acid free card may be used to back the work to show up the stitchery and design.

The small mat is a development of the sampler and the original tile concept, with a dove's eye filling and pearl beads both at the points and as part of the back stitch picot edging. The single line of bars and knots creates a less dominant pattern and is outlined by reversed diagonal faggoting.

Four of the smaller mats have been reversed and put together to form the larger. The simple pin stitch hem edging offsets the ornate embroidery. The dove's eye filling theme has been carried through without beads on the larger diamond shape, and with beads on the loops for the centre piece. Algerian eyelets with blending filament have been substituted for the faggoting to keep the centre light and open.

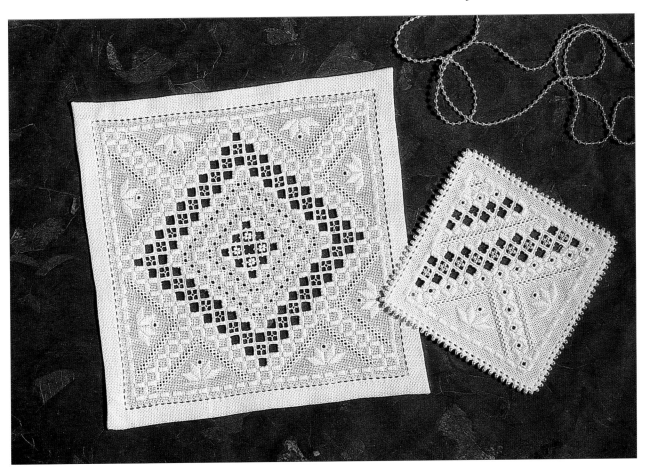

Tray Holder

A tray holder is a popular Scandinavian kitchen accessory or decoration, usually made of a woven cotton band and formed into a divided sling in which to balance the tray. This stylish version in Hardanger on a crisp white linen band is not only practical but will decorate any kitchen. A simple repeating tile design is filled with the attractive Greek cross filling and linked with the textured twisted lattice band stitch.

The finished, folded length depends on the size of your tray. In this case the sling measures 40.5cm (16in) to hold an average-sized tray. If you cannot find a suitable band, use fabric and leave enough seam allowance on either side of the design to make a decorative hem following directions on page 32.

There is scope to alter the design and you could look through the book to choose another variation to fill the square, link it with four-sided stitch or small bands or borders (see page 31), or choose coloured threads and fabric to match the colour scheme of your kitchen.

You will need

White linen evenweave band or suitable evenweave fabric 28 threads to the inch, width 5cm (2½in), length 175cm (69in) or four times the width of your tray plus 40cm (15¾in)

1 ball of coton perle No. 8 white

1 ball of coton perle No. 12 white

Blunt-ended tapestry needle, size 24/26

7.5cm (3in) diameter wooden or metal curtain ring

- Prepare the fabric band by tacking in the vertical centre line.

- Using the coton perle No. 8, start 6.5cm (2½in) down from the top of the band and follow the chart on page 50 to work two bands of the first five cross stitches of the twisted lattice band. Then complete the square of five kloster blocks.

- Fill the square with the single motif shape as shown.

- Repeat the design over the whole length of the band. Cut and withdraw any threads from the motif for the needleweaving and Greek cross filling (see page 28), which should then be worked using coton perle No. 12.

- If time is short, you could just work the two front parts of the tray holder which will show. In this event, construct the holder to ensure correct measurement of the length you will be stitching and the part you will leave blank. For this tray holder there are 6 repeat designs showing on the front of each arm.

- Wash and press the work carefully as directed on page 35.

- A wooden curtain ring will not require covering, but if using a metal one, work a close buttonhole stitch to cover the ring if preferred.

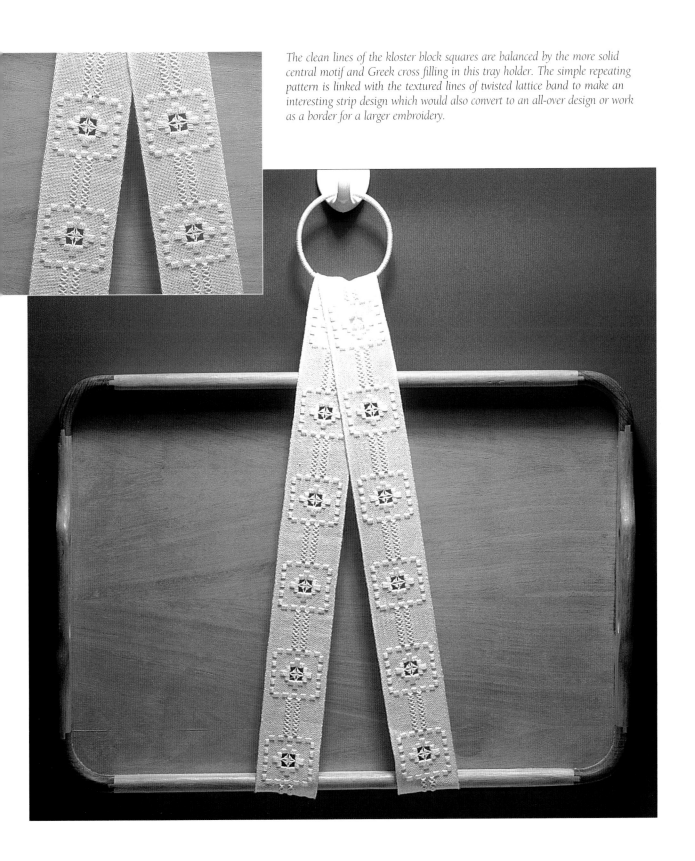

The clean lines of the kloster block squares are balanced by the more solid central motif and Greek cross filling in this tray holder. The simple repeating pattern is linked with the textured lines of twisted lattice band to make an interesting strip design which would also convert to an all-over design or work as a border for a larger embroidery.

Folding the tray holder

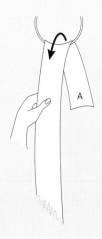 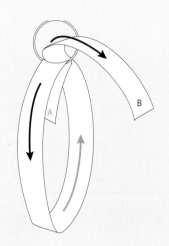 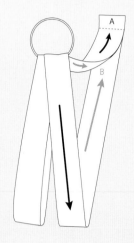

1. Loop the short end of the band (A) over your ring and hold in position.

2. Bring the other end (B) down, round and back up through the ring, following the directional arrows.

3. Adjust to make the two band loops level. Arrange the ends A and B to the correct length and stitch them together. Trim excess fabric and reorganise the seam back into the middle of the tray holder so that it will hang equally.

The chart for the Tray Holder embroidery on page 49

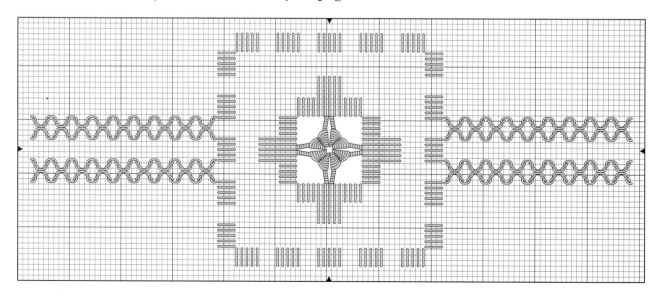

 Kloster blocks
Coton perle No. 8

Kloster block outline
Coton perle No. 8

 Twisted lattice band
Coton perle No. 8

 Needleweaving with Greek cross filling
Coton perle No. 12

On a larger scale with a different fabric count and multicoloured threads, the repeating design from the tray holder has been expanded into a flower pot cover. Changing the filling and adding beads to a back stitch picot edging creates another dimension to the design.

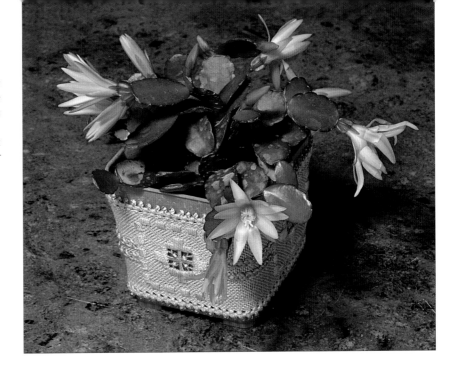

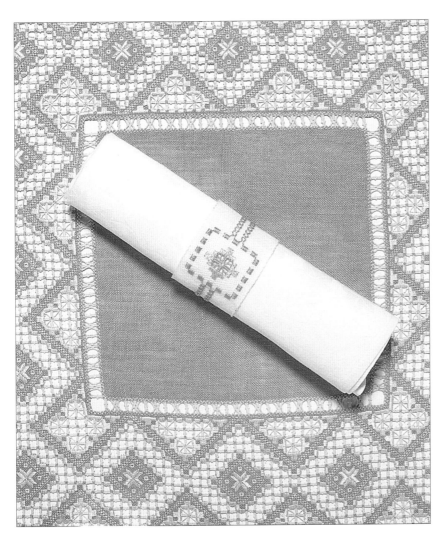

Here the design has been reduced to a single motif and the filling and threads have been changed to make a napkin ring.

Bridal Bag

A special bag of hearts and pearls for a special day. Decorated profusely with pearls and beaded fillings, this is a bag a bride will love to show off with her wedding dress. The design combines two of the original tile squares of eleven kloster blocks, with the side triangles opened completely to get the maximum effect of the beaded square filet filling. Algerian eyelets echo and lighten the central diamond and offset the heart motif which, in turn, is echoed as a border to the bag.

Enlarge the chart on page 54 on a photocopier so that you can see the details.

- Prepare the fabric as described on page 32 and tack in the centre horizontal and vertical guide lines.

- Using coton perle No. 8 and following the chart on page 54, come to the surface at A, 38 threads down from the centre point and two threads to the right to stitch the kloster blocks which outline the centre diamond shape.

- Echo the kloster blocks round the central diamond and build up the rest of the kloster block pattern from this shape.

- Stitch the outside border of kloster blocks, working round the design from the top line of blocks; this will make it easier to count and help prevent counting errors.

- Complete all surface stitchery of hearts.

- Change to coton perle No. 12 and sew the Algerian eyelets before cutting and embellishing the grids.

- Cut and withdraw the threads, then embellish and complete each triangle individually and in sequence.

- Work the beaded square filet filling as shown or choose you own preferred filling.

- Back stitch all the single pearls into position as shown on the chart. Embroider one or both sides of the bag as preferred.

- Wash and press the work carefully, especially as there are beads in the piece (see page 35).

You will need

2 pieces of white evenweave 25 threads to the inch, 25.5 x 29.2cm (10 x 11½in)

2 pieces of silk or suitable lining fabric, 25.5 x 29.2cm (10 x 11½in)

1 ball of coton perle No. 8 white

1 ball of coton perle No. 12 white

Blunt-ended tapestry needle, size 24/26

One or two 7.5cm (3in) metal curtain rings or decorative Indian type bangles

Approx. 325 pearl beads

Short tapestry needle size 10 for needleweaving and incorporating beads with fillings

Satin ribbon 2.5 x 5cm (1 x 2in) for a single tab

Opposite

The finished Bridal Bag, size: 15.2 x 19cm (6 x 7½in). The bag is an extension of the sampler design, changing the lines to give larger areas of filling stitches. The pearl beads are bigger than seed beads and take over the stitch, filling the square to give a heavily beaded look. Calming spaces are provided by the centre panel and simple border.

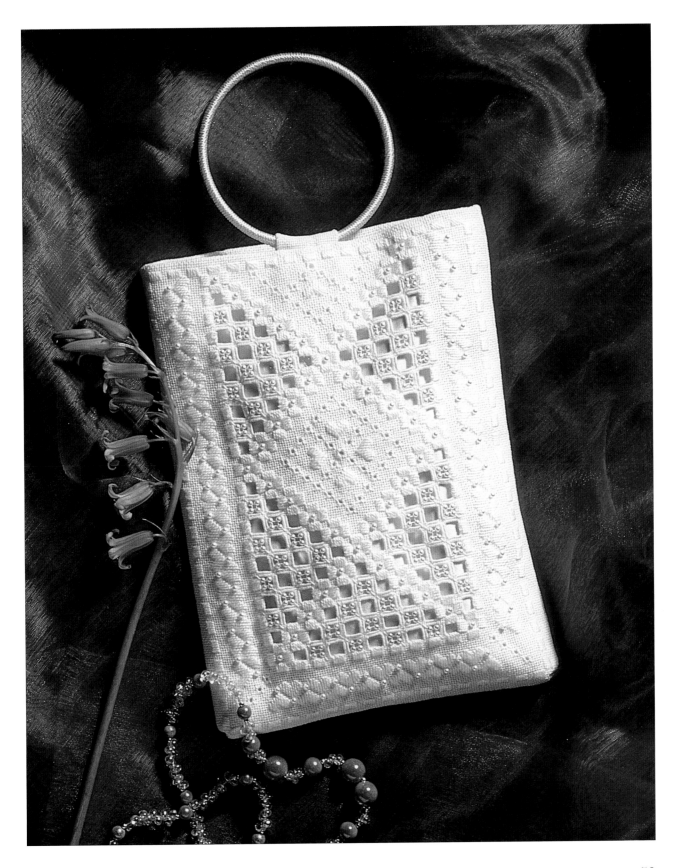

- To complete the bag and make a small gusset, machine up the sides and bottom seams, six threads away from the outlining kloster block border. It is a good idea to tack the lines into position first to ensure accuracy. Stitch the lining in the same way to the same measurements as the inside of the bag.

- Trim away excess fabric to 13mm (½in) seam allowance and gently press open the seam. To form the gusset, place one side seam on top of the bottom seam to form a point at the corner. Tack, then machine across the point (as indicated by the pin shown in the picture) no more than six threads' width either side of the seam to create a gusset of twelve threads in total, when the bag is turned inside out. Repeat the process for the other side and the lining.

The chart for the Bridal Bag embroidery on page 53

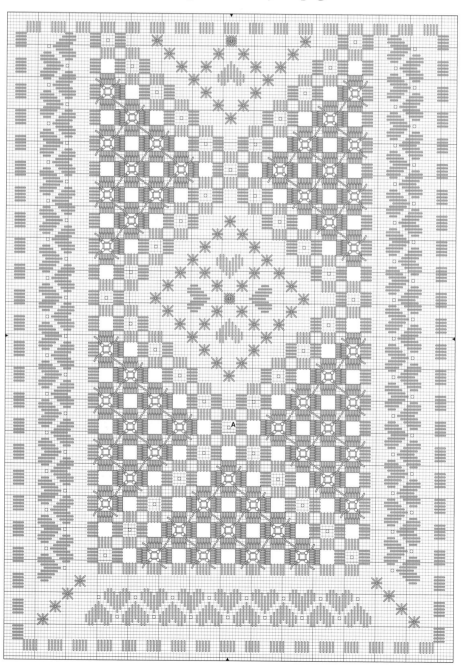

Kloster blocks
Coton perle No. 8

Satin stitch hearts
Coton perle No. 8

Square eyelet
Coton perle No. 12

Algerian eyelets
Coton perle No. 12

Needleweaving with beaded
square filet filling
Coton perle No. 12

○

Pearl beads

- Fold over the top edge of the bag to the inside, four threads away from the top line of blocks.

- If appropriate, buttonhole stitch round the handle ring or rings.

- Use the satin ribbon to make a tab to hold the handle rings in place. Loop the ribbon over the ring or rings, centre and stitch to the inside lip edge of the bag. Place the lining in the bag, wrong side to wrong side of fabric, and turn the raw edge to the inside, just slightly lower than the top of the bag. Cover the raw edges of the tabs and hem the lining in position.

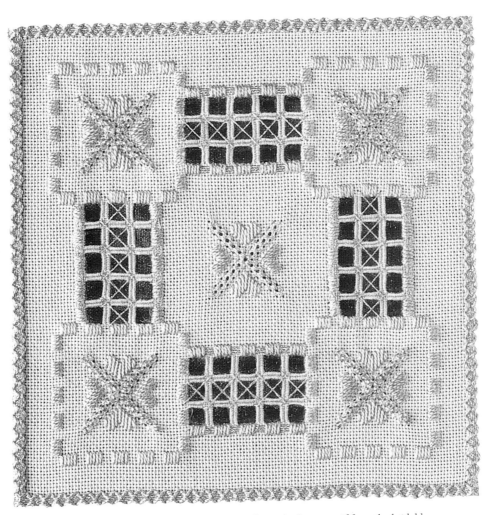

This ornate embroidery for a book cover combines the heart motif from the bridal bag with an extension of the tray holder design, worked into a square and bordered with twisted lattice band. The heart motif is divided by reversed diagonal faggoting, with beads included in the centre stitching line for the corner motifs to create a contrast of texture. The woven bars are decorated simply with a wrapped herringbone stitch to link the theme, but cross stitches would have worked as well.

Curtain Tie-Back

Add that final 'statement' to your decor with this stylish curtain tie-back. Pick out the colours for the surface stitchery to contrast with the single lines of open needleweaving through which to see the curtain. You can use shaded threads, coloured fabrics or painted backgrounds to stitch appropriate curtain tie-backs for any room in your house and to match any fabric, plain or patterned.

- Prepare the fabric band by tacking in the centre horizontal line.

- Using the white cotton perle No. 8, establish the design with the outer square of kloster blocks, starting 6.4cm (2½in) from the end of the band, with your first stitch twenty-six threads down and two threads to the right of the central horizontal line at A, as shown. Repeat to form the inner square.

- Outline the square with twisted lattice band in line with the kloster blocks using coton perle No. 8. Centre the satin stitch star in the square with the same thread.

- Alternate the twisted lattice bands with the kloster block squares to avoid mistakes in the counting. Work as many repeats as you need.

- Cut and withdraw the threads between the two kloster block squares and needleweave with white coton perle No.12.

- If you cannot find a suitable band, use fabric and leave enough seam allowance on either side of the design to make a decorative hem (see page 32).

- Wash and press the work carefully as directed on page 35.

- Fold over to the back a seam allowance of 1cm (³⁄₈in) at the end of the band and mitre to the centre horizontal line to form a point. Slip stitch the two sides together. Take the point of the band through the curtain ring and sew to secure the ring into place. Repeat the process for the other end.

You will need

White linen evenweave band or suitable evenweave fabric 28 threads to the inch, width 9cm (3½in) or similar, length to suit your curtains

1 ball coton perle No. 8 white

1 ball coton perle No. 12 white

1 ball coton perle No. 8 pale green

2 brass curtain rings

Opposite

The finished Curtain Tie-Back. A simple Greek key pattern decorates the tie-back, with open needlewoven bars to reveal the curtain, bordered by twisted lattice band.

Make whatever length of tie-back you need to suit your curtains. In this case the tie-back measures 66cm (26in) and has nine repeats of the design. Each square repeat measures 5.7cm (2¼in) on fabric 28 threads to the inch, but the size will vary according to the fabric count being used.

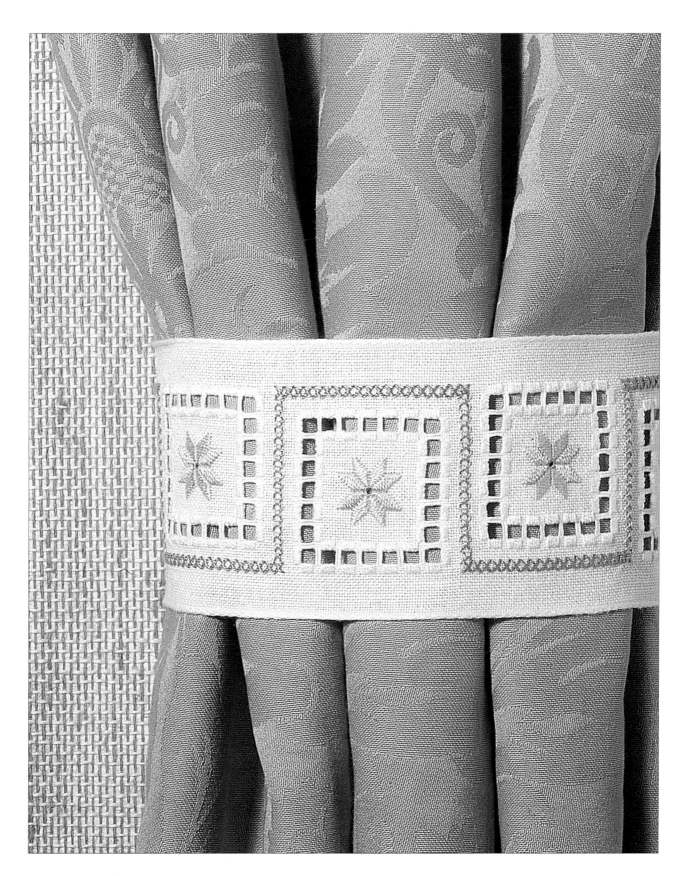

The chart for the Curtain Tie-Back on page 57

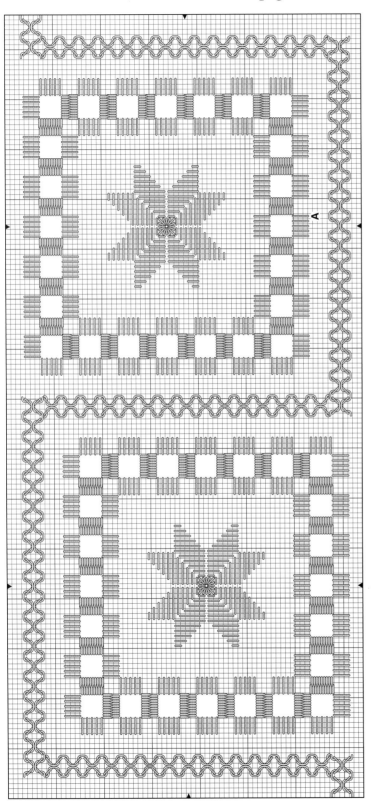

To follow this chart, turn the book so that the A is the right way up.

Kloster blocks
White coton perle No. 8

Needleweaving
White coton perle No. 8

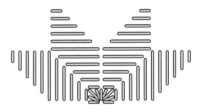

Satin stitch star
Pale green coton perle No. 8

Twisted lattice band
Pale green coton perle No. 8

Opposite

Transfer-painted fabric with a simple pin stitch hem changes the look in this variation of the tie-back, which also features hand-dyed yarn and an open filling. The same design could easily be turned into a border for a larger project.

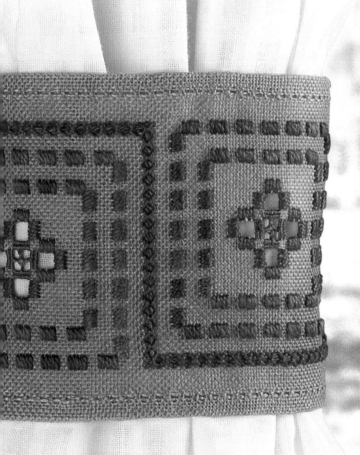

Cushion Cover

A mosaic of nine tiles decorates this simple concept for a cushion cover, to fit in any surrounding and to work with any colour scheme. Tied with ribbons at each side, this is a practical way of covering an old cushion or making use of a silk pad in a contrasting colour to show off the design. The understated, clean lines of the squares are embellished simply with beaded dove's eye filling for sparkle and texture and separated with four-sided stitch over two threads and square eyelets.

The design can be varied to suit other projects either by adding or reducing the number of squares or by changing the size of the background fabric. A single square could be inserted in a greetings card.

- Prepare the fabric as described on page 32 and tack in the centre guide lines vertically and horizontally.

- Establish the design following the chart, starting with the centre square. To work the first kloster block, bring the needle to the surface at A, twenty-two threads down from the centre and two threads to the right. Use pearl cotton No. 8 and stitch in a clockwise direction to form the inner square.

- Outline each square with kloster blocks and work the satin stitch stars as shown in pearl cotton No. 8.

- Divide the squares with four-sided stitch (over two threads) and eyelets using pearl cotton No. 12 and blending filament.

- Cut and withdraw the appropriate squares and fill with dove's eye filling with beads at the points.

- Wash and press the work as directed on page 35, taking particular care since there are beads in the piece.

- Leave a 5cm (2in) border round the design before turning the fabric to the back to form a 5cm (2in) hem. Turn up a seam allowance of approx 1cm (³⁄₈in) and invisibly slip stitch the hem on the wrong side.

- Centre the ribbons in the middle of the outside embroidered squares (on all sides of the cushion) and sew them in place on the wrong side, 2 cm (³⁄₄in) down from the edge.

You will need:

2 pieces of white evenweave 25 threads to the inch, 40.5cm (16in) square for the back and front of the cushion cover

1 ball of pearl cotton No. 8 white

1 ball of pearl cotton No. 12 white

Iridescent blending filament

Covered cushion pad size: 28cm (11in square) or as preferred

Blunt-ended tapestry needle, size 24/26

186 size 11 seed beads to match or contrast as wished

Short tapestry needle size 10 (or similar) for needleweaving and incorporating beads

2 metres of ribbon for ties (you will need more if you prefer bows)

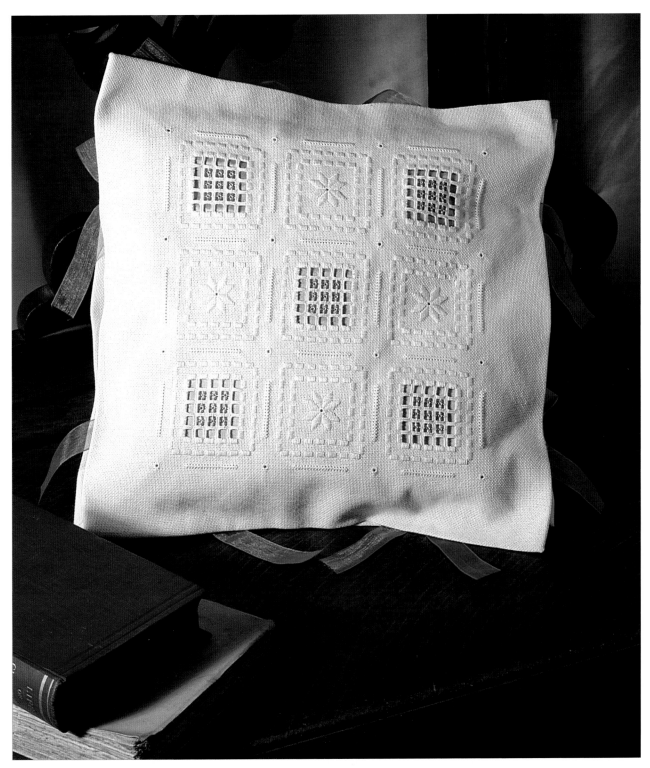

A mosaic of tiles form the minimalist design for this cushion cover, which relies on the contrast between the decorative dove's eye filling with beads at the points and the rich satin stitch stars for its impact. Any of the fillings could be substituted in the squares and the design would work well as a repeating pattern for a bigger project. This cushion cover is 30.5cm (12in) square, but make yours to fit your chosen cushion.

- Complete the back of the cushion cover in the same way. Tie ribbons in knots or bows to enclose the cushion pad. If a coloured lining is required to show up the design or hide an old cushion, cut the chosen lining fabric to fit the finished size of the cushion. Turn the hem allowance over the lining and stitch to the lining.

The chart for the cushion cover embroidery on page 61

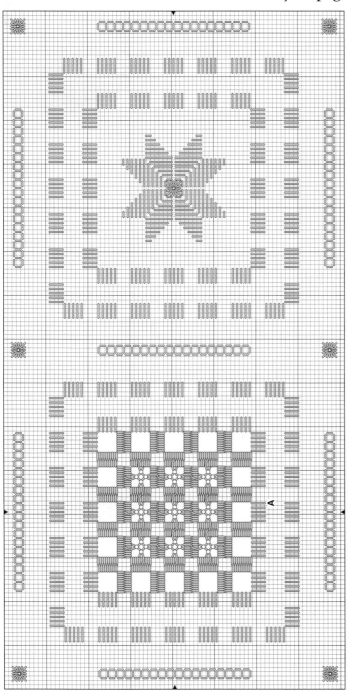

To follow this chart, turn the book so that the A is the right way up.

Kloster blocks
Pearl cotton No. 12

Satin stitch star
Pearl cotton No. 8

Four-sided stitch over 2 threads
White pearl cotton No. 12 with iridescent
blending filament

Square eyelets
White pearl cotton No. 12

Needleweaving with beaded dove's eyes
Pearl cotton No. 12

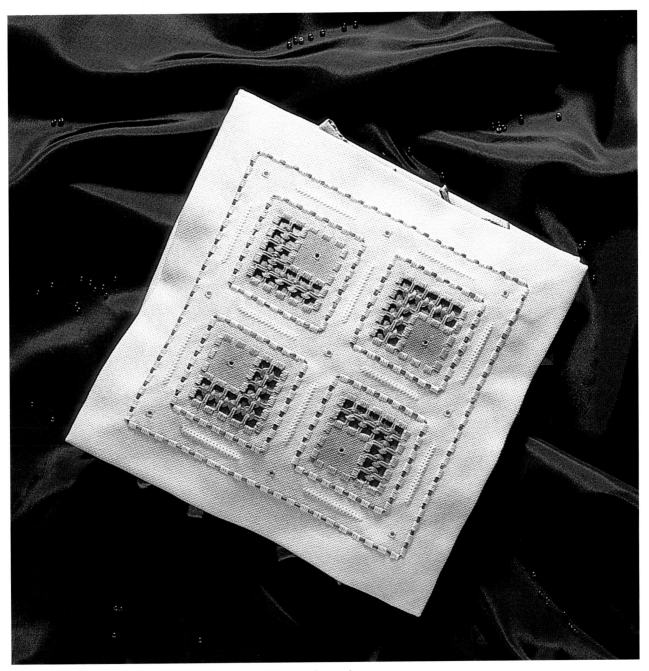

This variation on the cushion cover design features transfer-painted central squares outlined with kloster blocks in a matching colour and offset at different angles. The woven bars are decorated with linked circles to soften the lines of the squares and backed with matching green silk. This could expand into an appealing all-over design with lots of scope for further developments.

Index

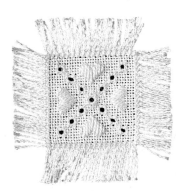